image comics presents

RICK CRIMES COLORING BOOK

For SKYBOUND ENTERTAINMENT

Robert Kirkman - Chamma Chamma Saan MacKlewicz - Editoral Drector Shawm Kirkham - Dector of Business Development Brian Huntington - Coline Editoral Drector June Allan - Publich Drector June Allan - Publich Drector Arrelle Basich - soliant Editor Arrelle Basich - soliant Editor Arrelle Basich - soliant Editor Andres Juneza - Graphic Designe Stephan Murillo - Business Development Assistant Johnny O'Dell - Order Editorial Assistant Dan Petersen - Operations Vocariator Nick Palimer - Operations Voc

International inquiries: foreign@skybound.com Licensing Inquiries: contact@skybound.com WWW.SKYBOUND.COM

IMAGE COMICS, INC

Mare Bilvestri - Chief Escoulov Officer
Jim Valentine - Vicio-President
Brite Bisphesses - Publisher
Art Bisphesses - Publisher
Art Bisses - Director of Publishing Planning & Book Trade is
Jeff Bisses - Director of Publishing Planning & Book Trade is
Jeff Bisses - Director of Publishing Planning & Book Trade is
Jeff Bisses - Director of Pig All Fastering
Art Salarse - Director of Pig All Fastering
Art Salarse - Director of Pig All Fastering
Brew Gill - Art Director
Brew Gill - Art Director
Art Salarse - Director of Pig All Fastering
Brew Gill - Art Director
Art Salarse - Director of Pig All Fastering
Brew Gill - Art Director
Art Salarse - Director of Pig All Fastering
Brew Gill - Art Director
Art Salarse - Director of Pig All Fastering
Brew Gill - Art Director
Art Salarse - Director of Pig All Fastering
Brew Gill - Art Director
Art Salarse - Director of Pig All Fastering
Brew Gill - Art Director of Pig All Fastering
Brew Gill - Art Director of Pig All Fastering
Brew Gill - Art Director of Pig All Fastering
Brew Gill - Art Director of Pig All Fastering
Brew Gill - Art Director of Pig Brew Gill - Art Di

Meredith Wallace - Print Manager Brish Skelly - Publicist Sasha Head - Saise & Marketing Production Designs Randy Okamura - Digital Production Designer David Brothers - Branding Manager Olivia Ngal - Content Manager Addis

Leanna Gaunter - Accounting Assistant
Chice Ramos-Peterson - Library Market Sales Represent
IMAGECOMICS.COM

THE WALKING DEAD RICK GRIMES COLORING BOOK. First Printing. ISBN: 978-1-5343-0003-3. Published by Image Comics, Inc. Office of publication: 2001 Center Street, 6th Floor, Berkeley, California 94704. Copyright © 2016 Robert Kirkman, LLC. All rights reserved. THE WALKING DEAD ™ (including all prominent characters featured in this issue), its logo and all character likenesses are trademarks of Robert Kirkman, LLC, unless otherwise noted. Image Comics® and its logos are registered trademarks and copyrights of Image Comics, Inc. All rights reserved. No part of this publication may be reproduced or transmitted, in any form or by any means (except for short excerpts for review purposes) without the express written permission of Image Comics, Inc. All names, characters, events and locales in this publication are entirely fictional. Any resemblance to actual persons (living and/or dead), events or places, without sattric intent, is coincidental. For information regarding the CPSIA on this printed material call: 203-595-3636 and provide reference # RICH − 706724. PRINTED IN THE USA

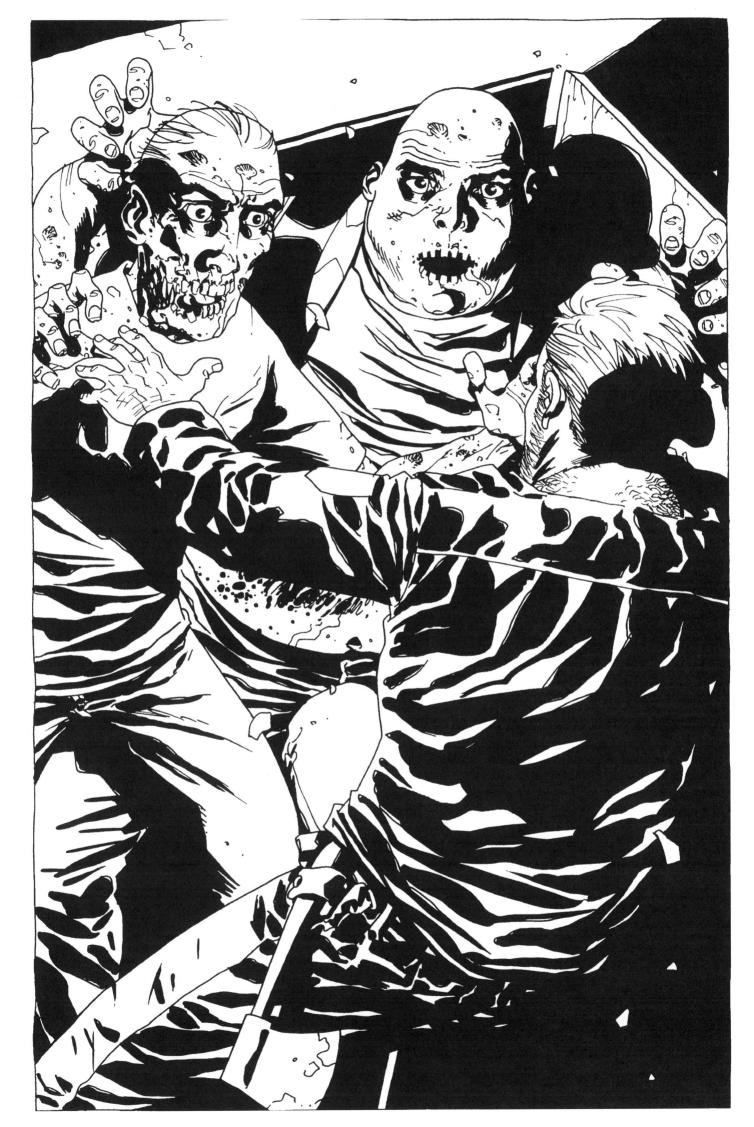

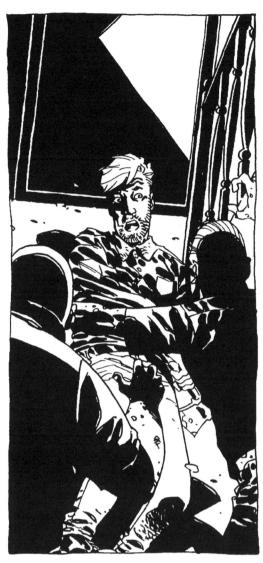

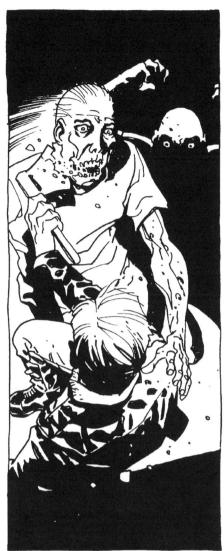

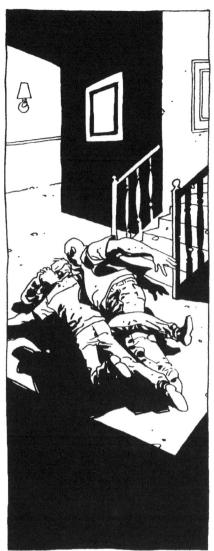

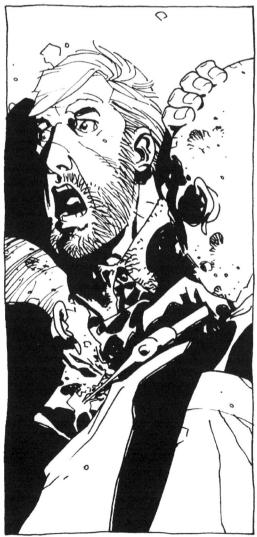

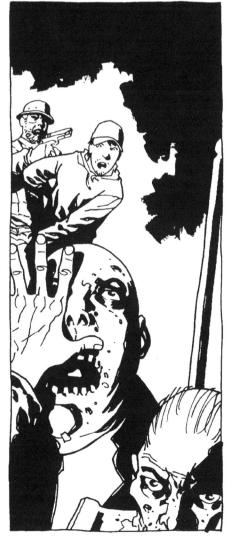

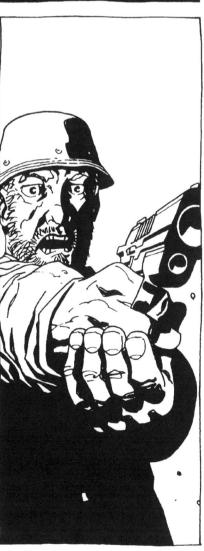

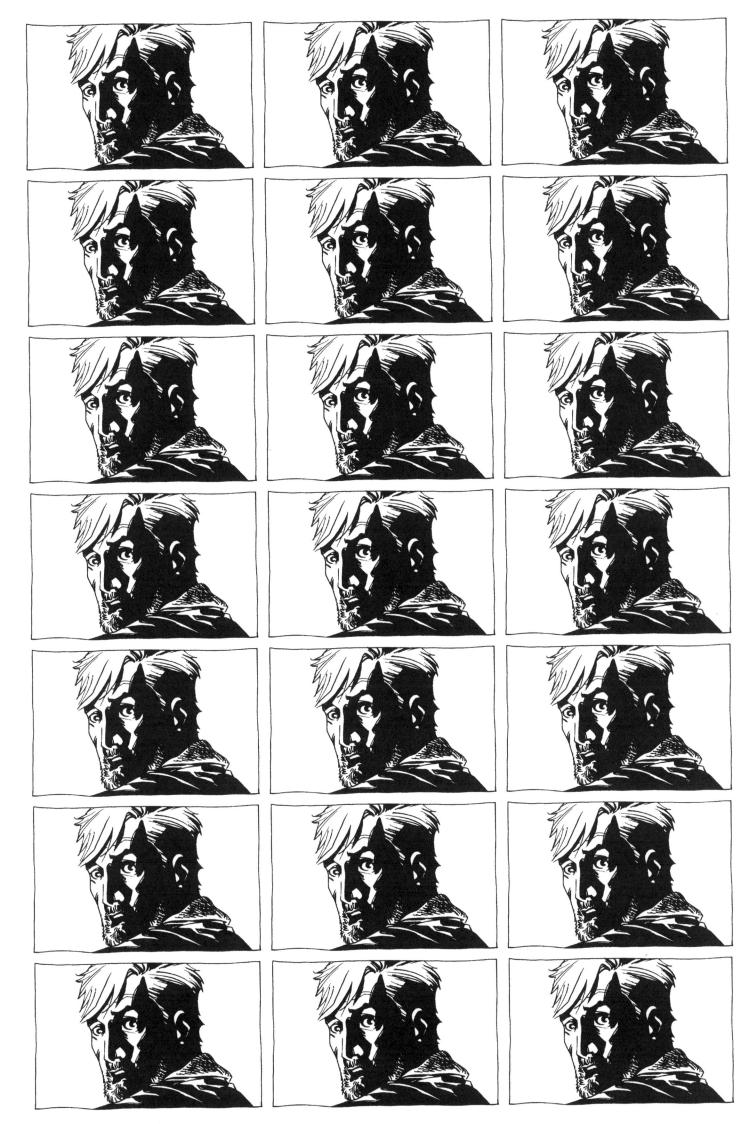

				5	
-					
				χ.	

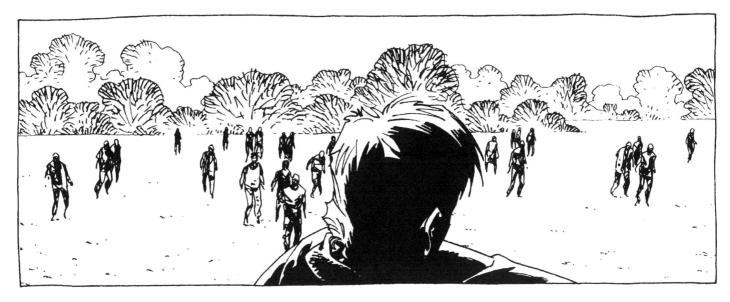

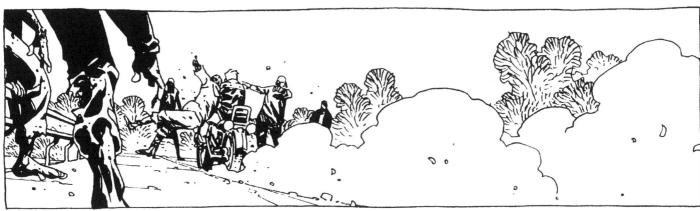

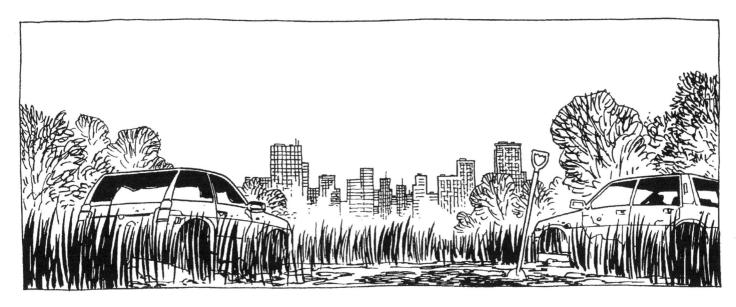

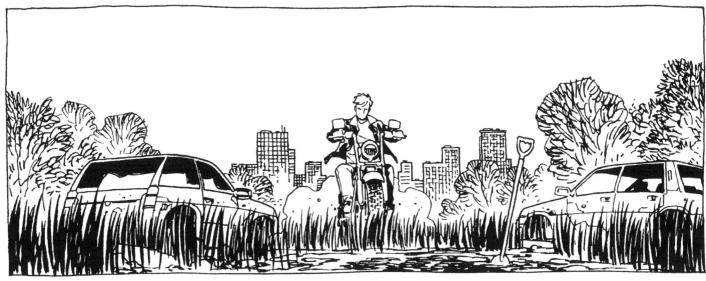

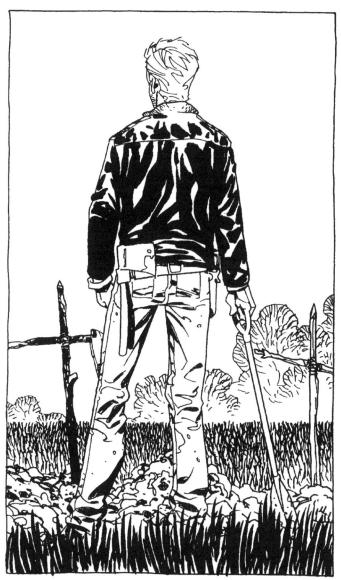

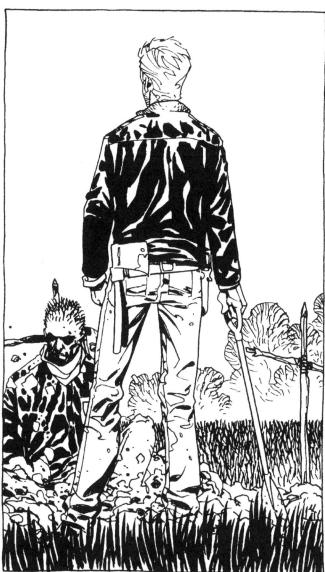

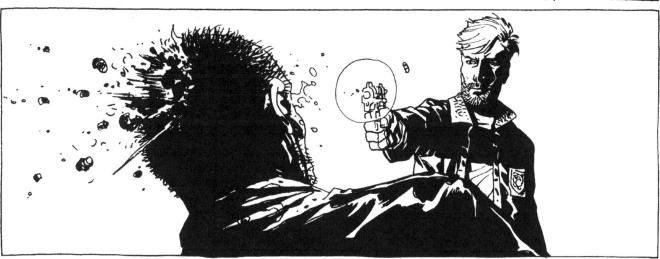

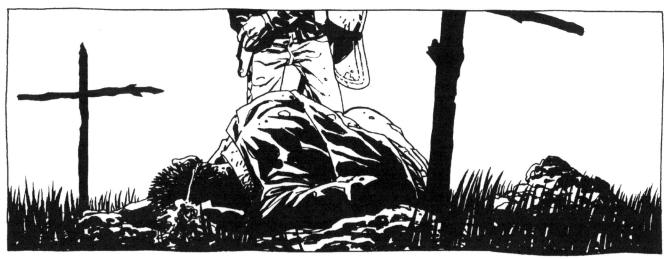

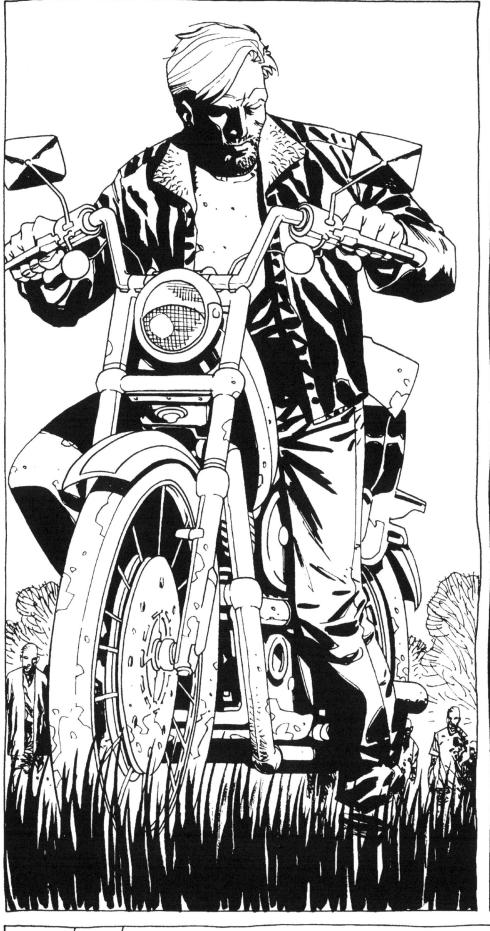

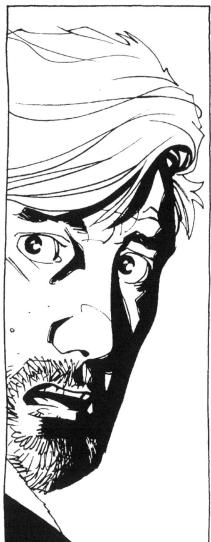

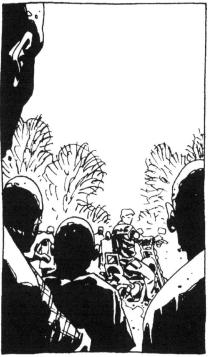

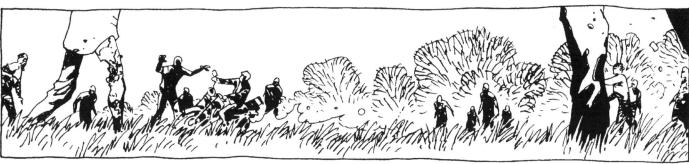

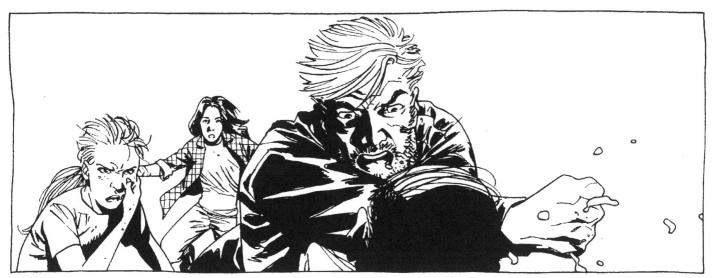

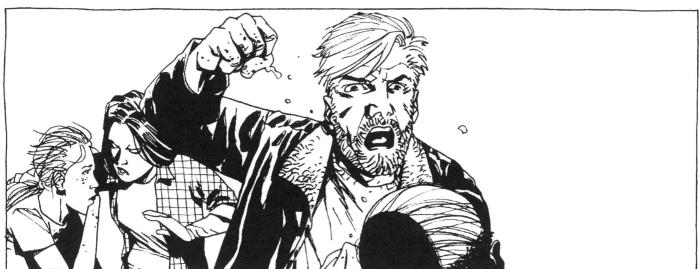

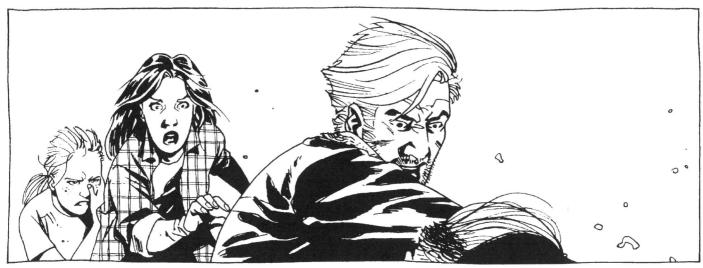

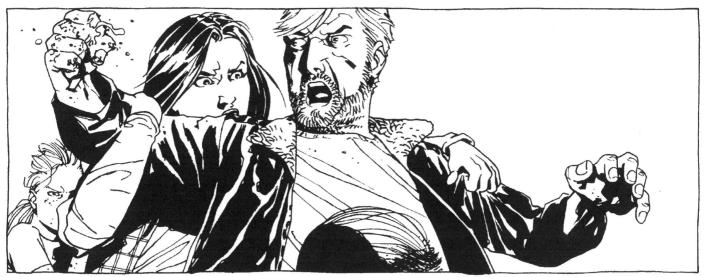

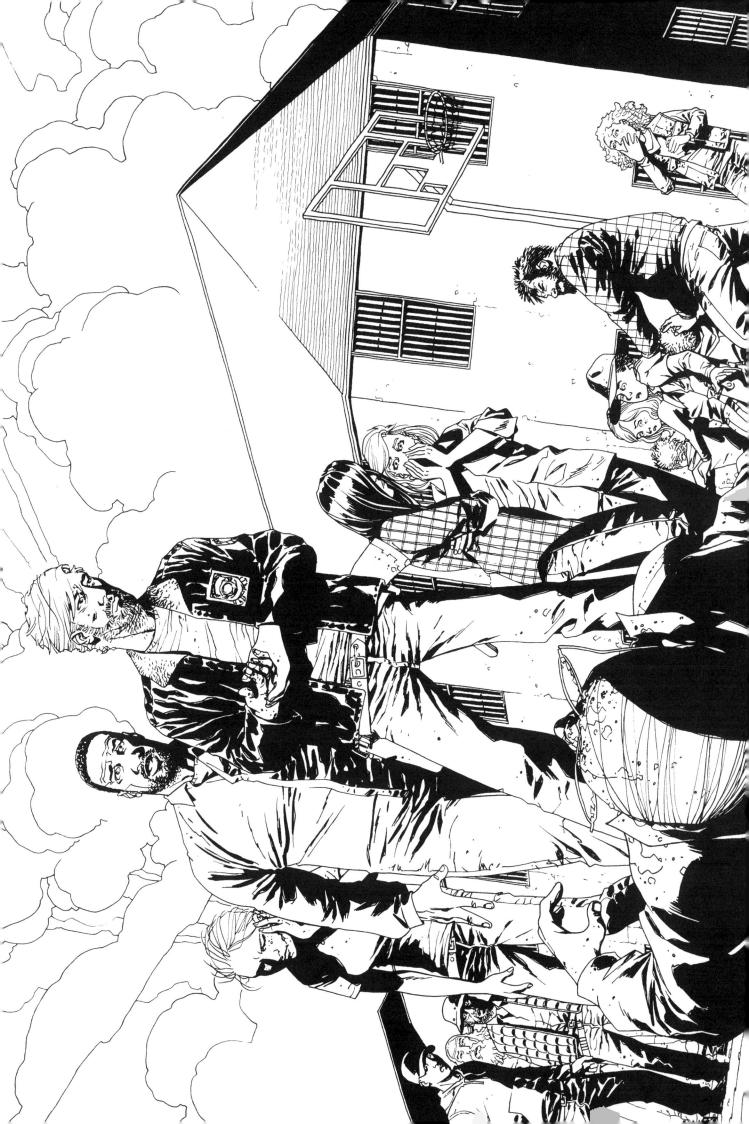

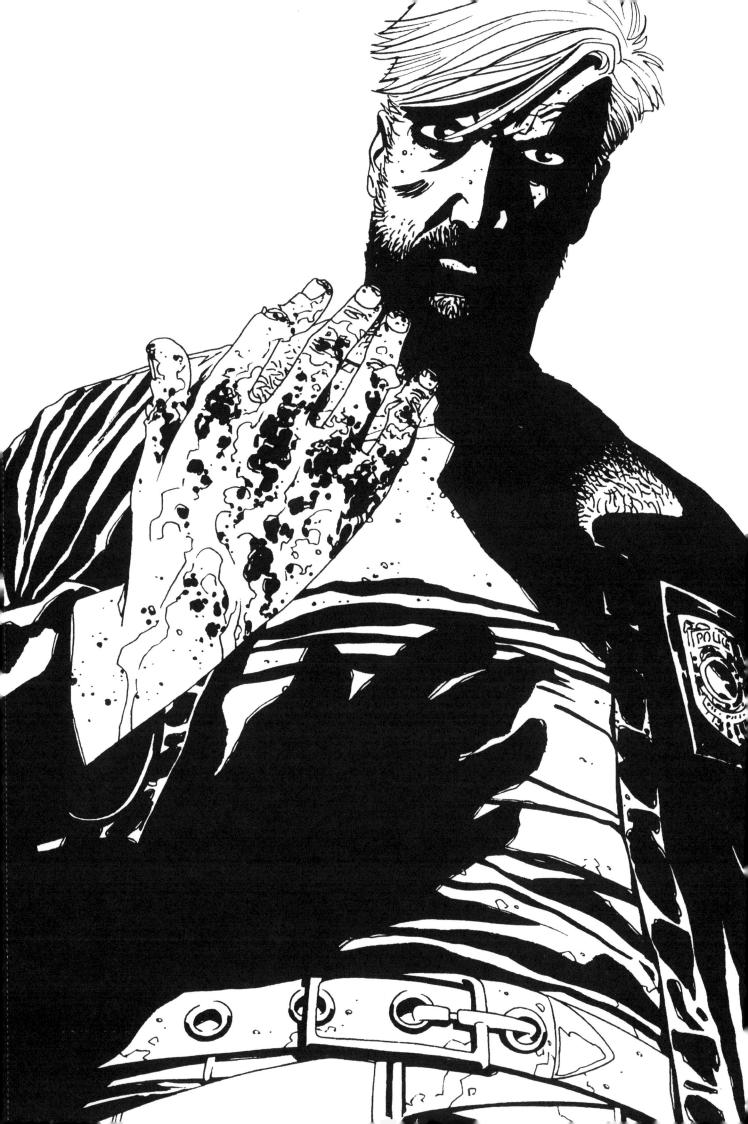

.

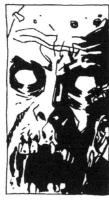

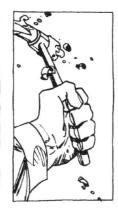

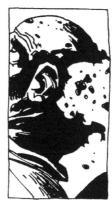

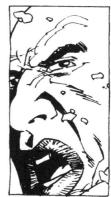

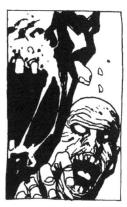

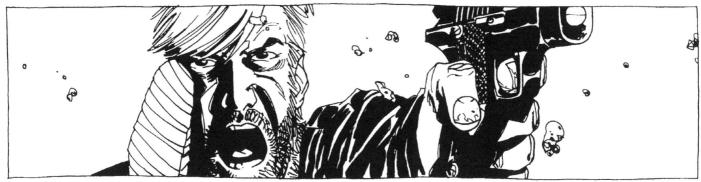

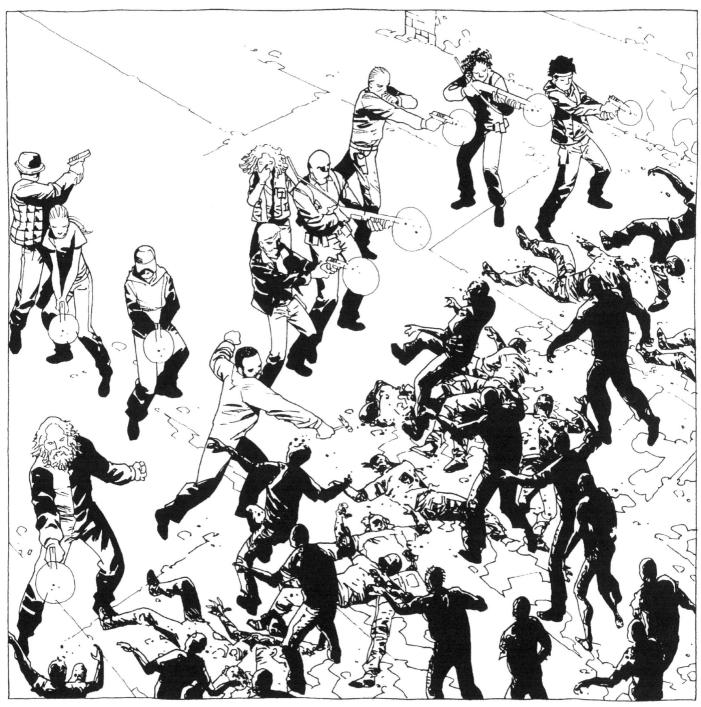

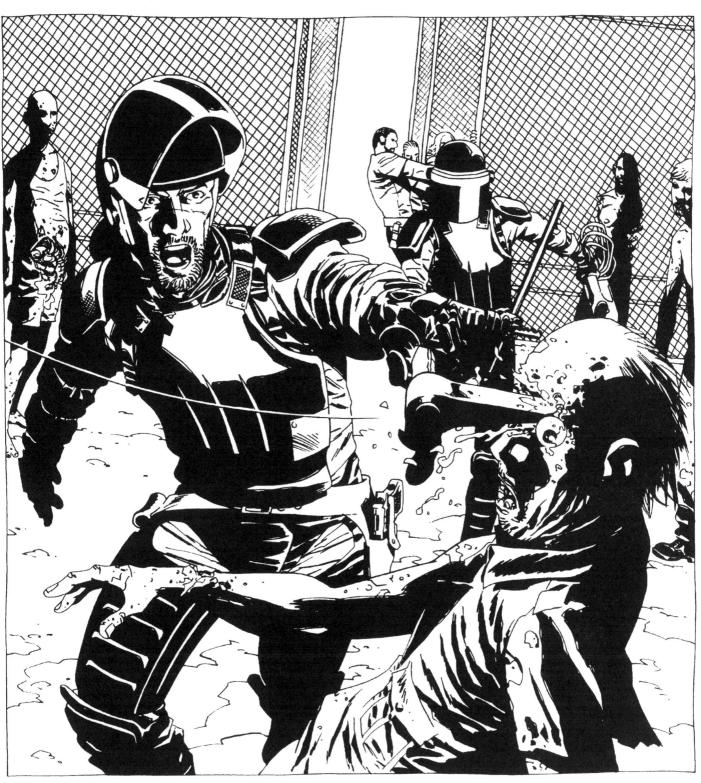

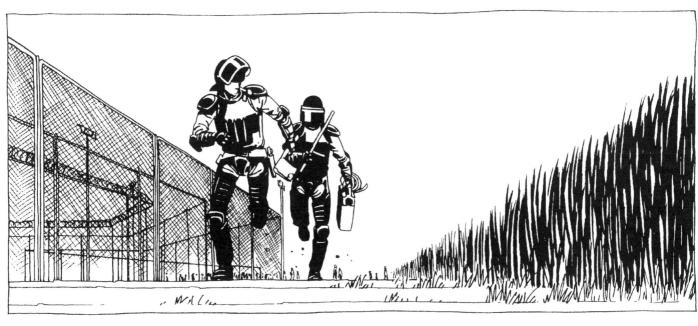

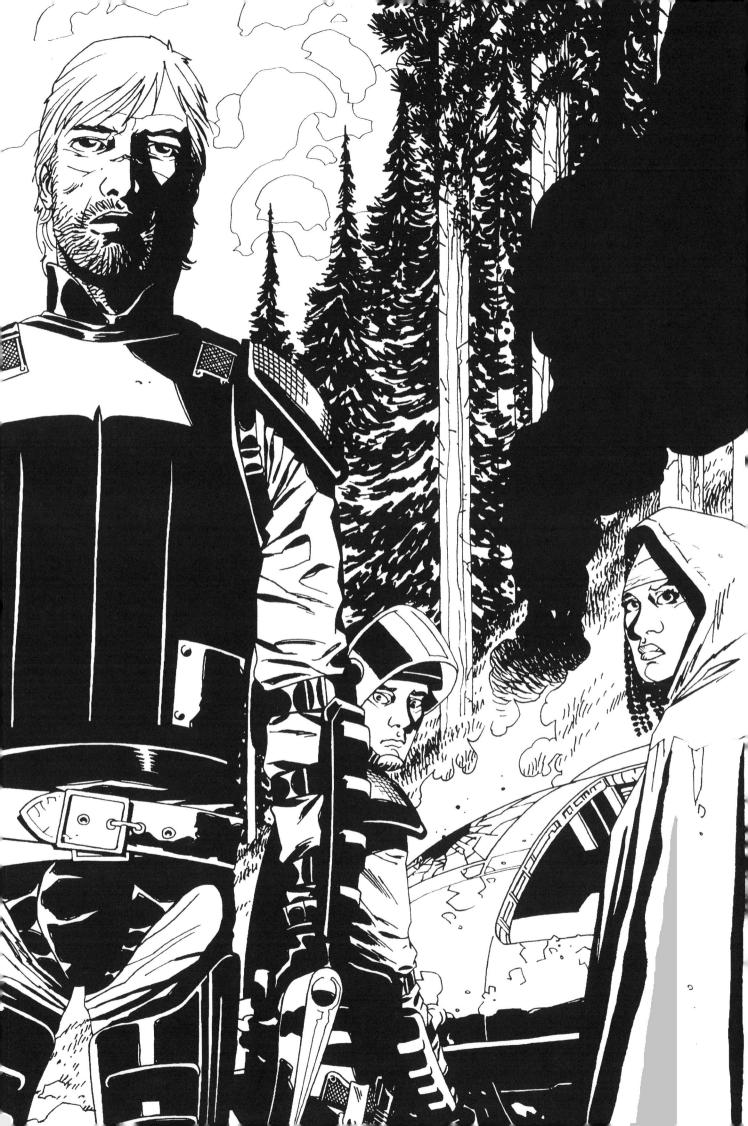

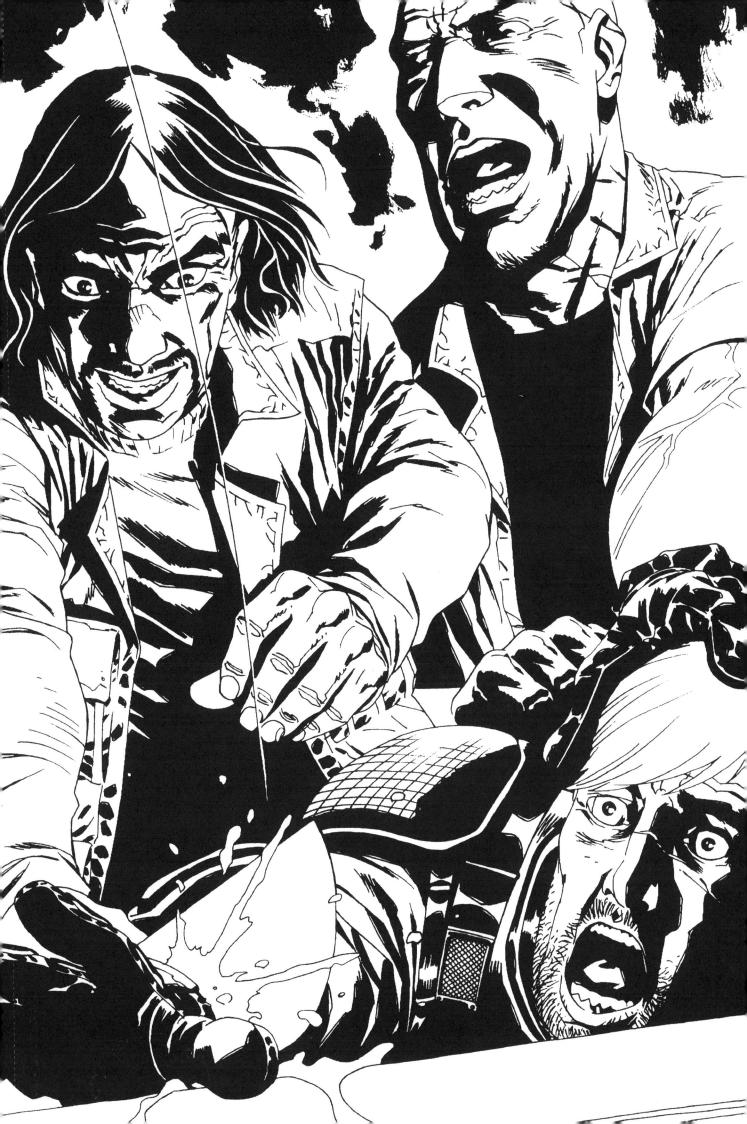

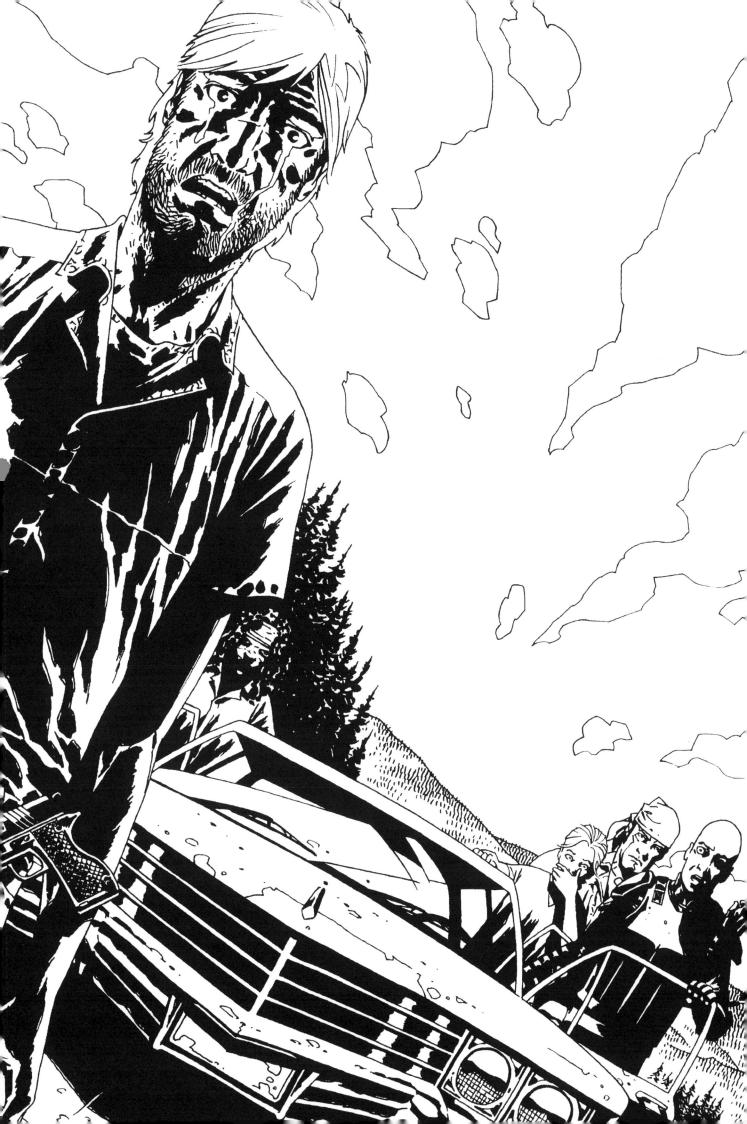

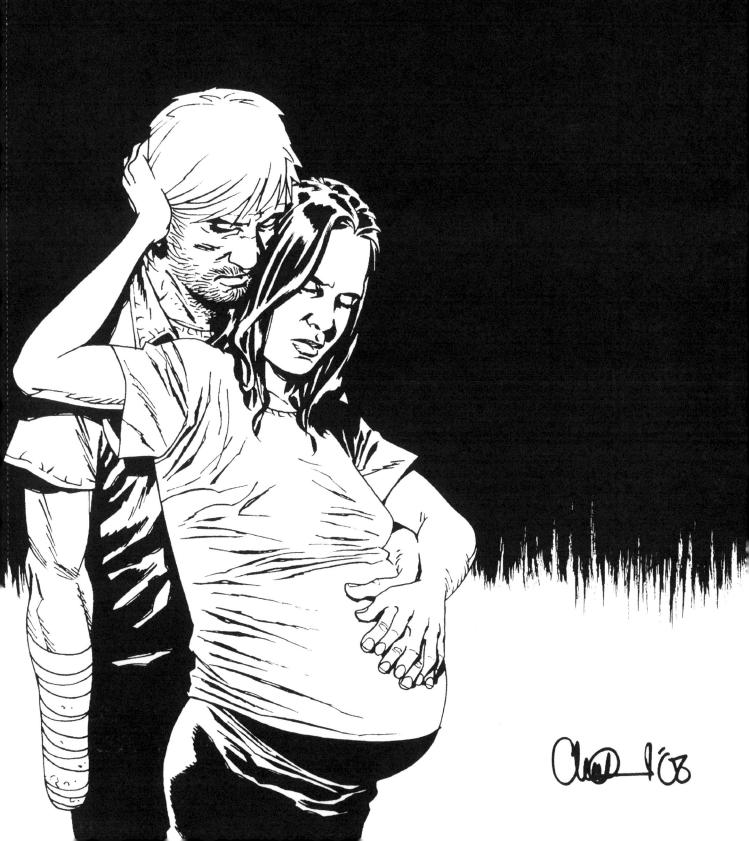

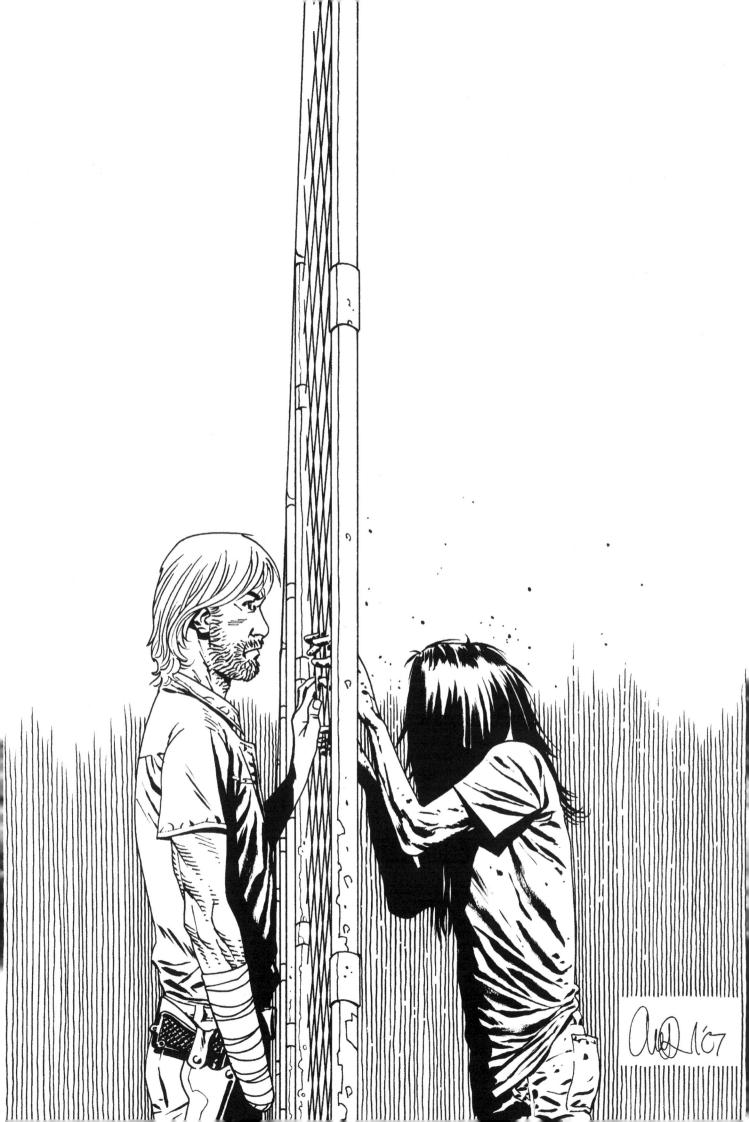

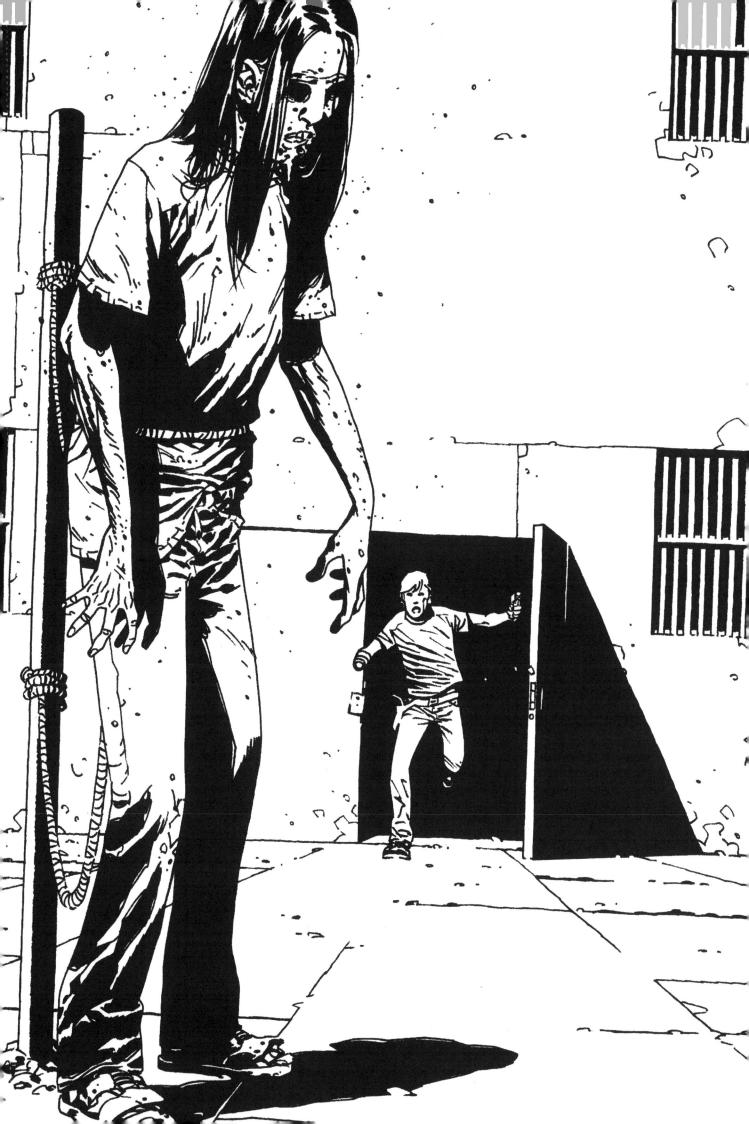

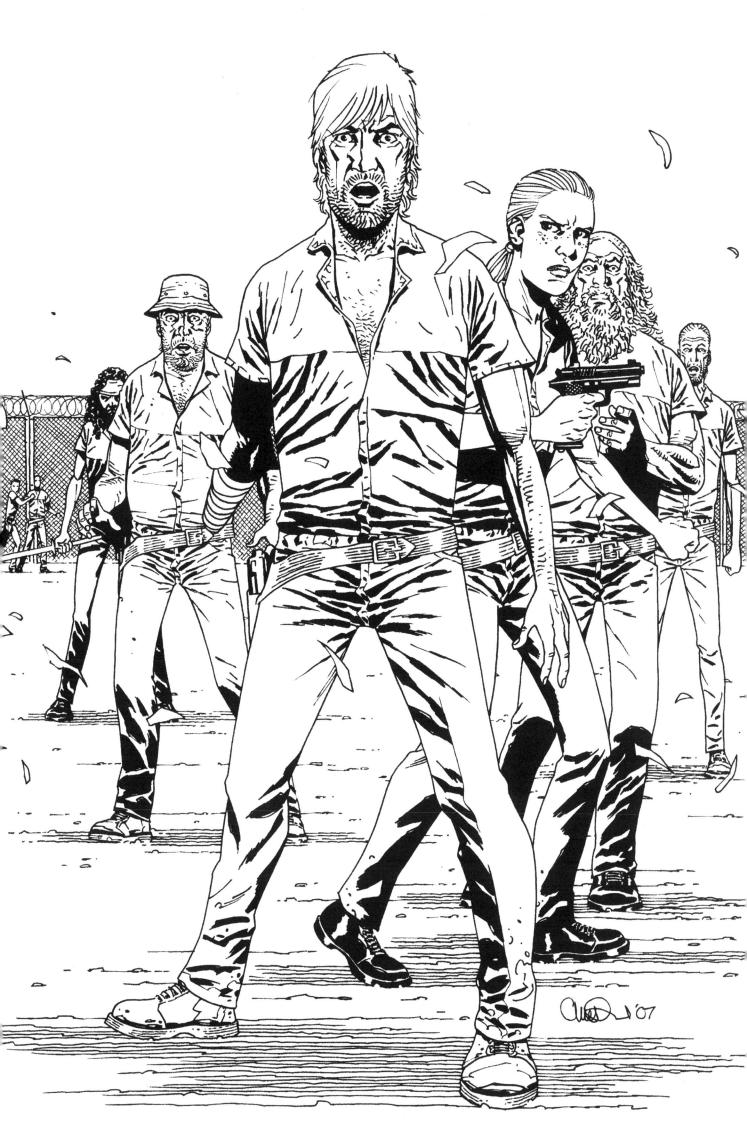

•

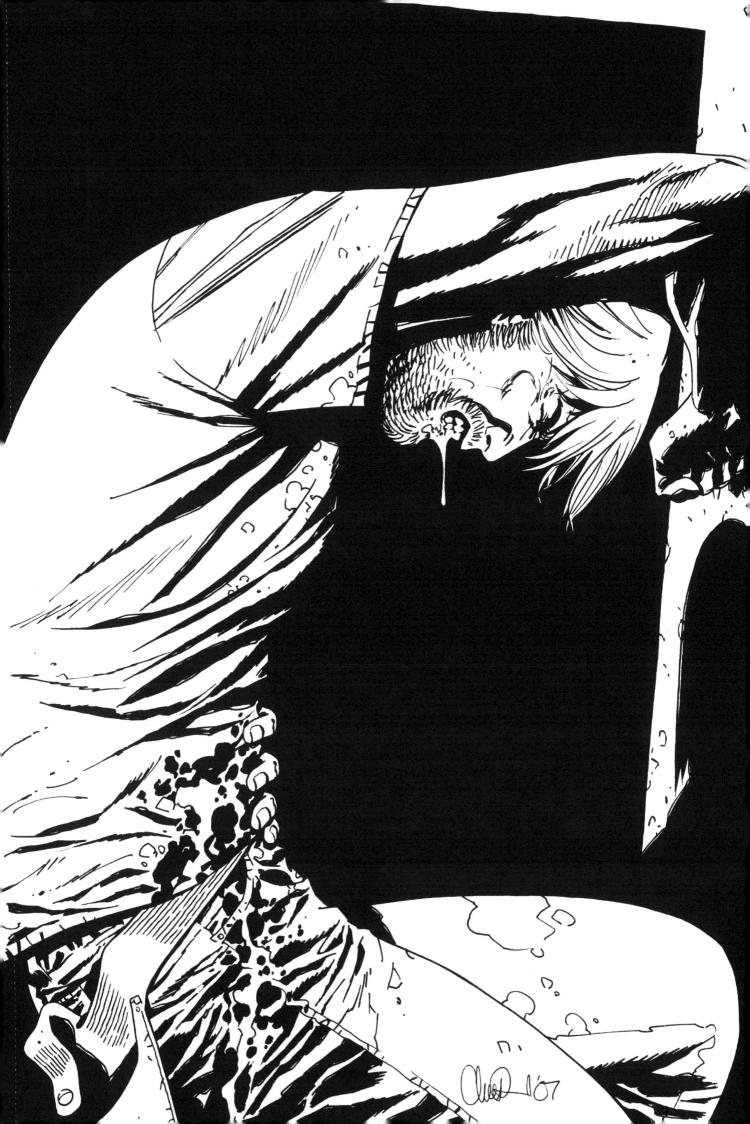

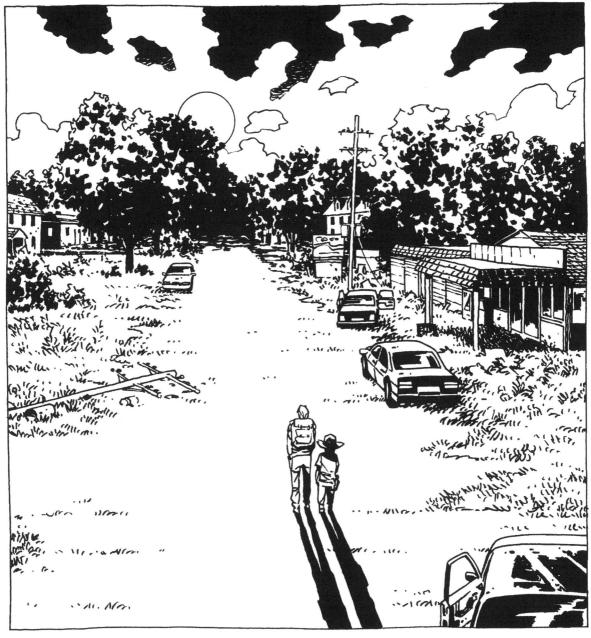

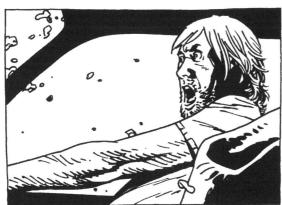

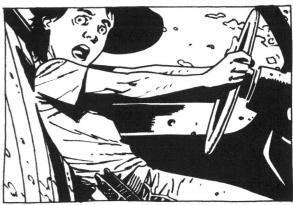

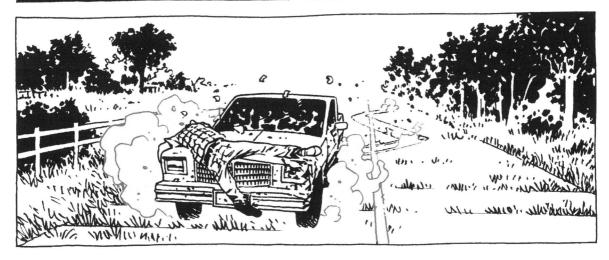

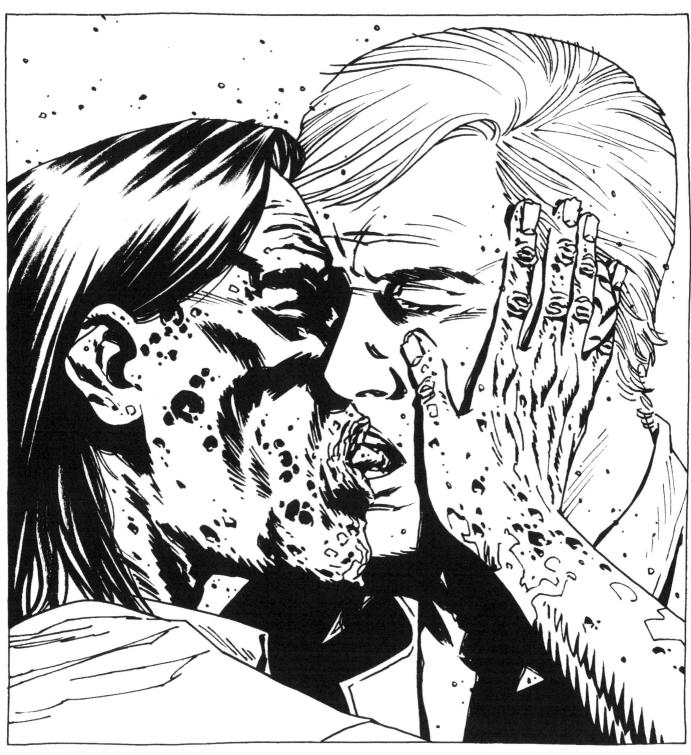

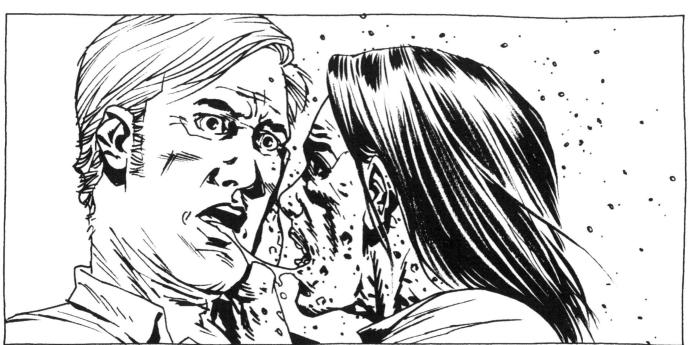

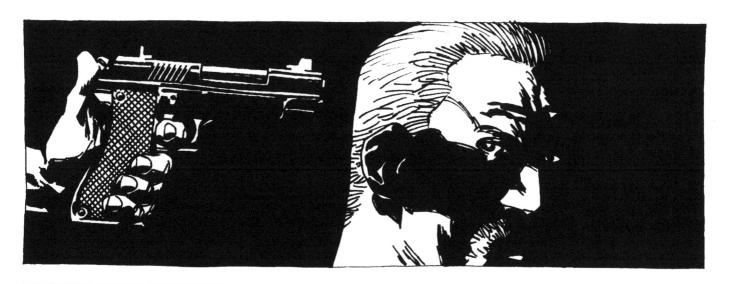

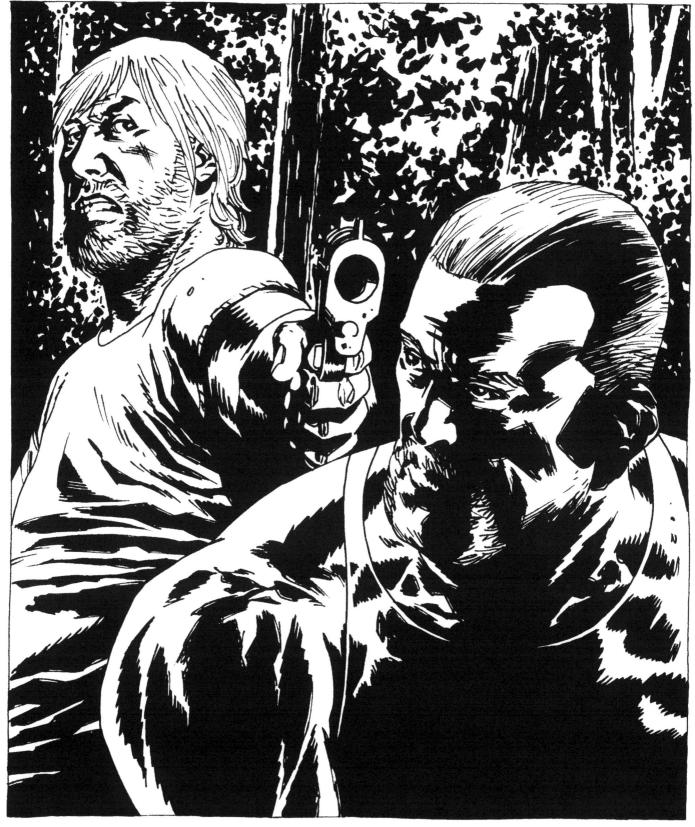

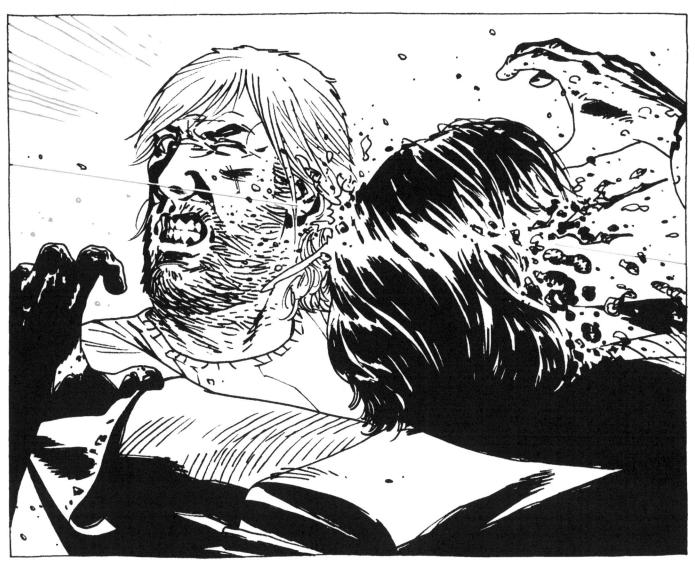

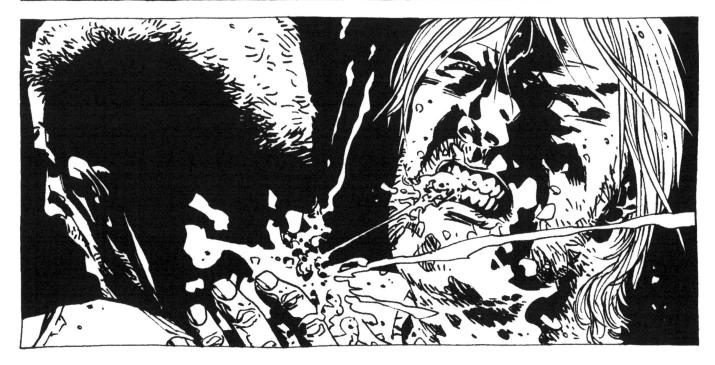

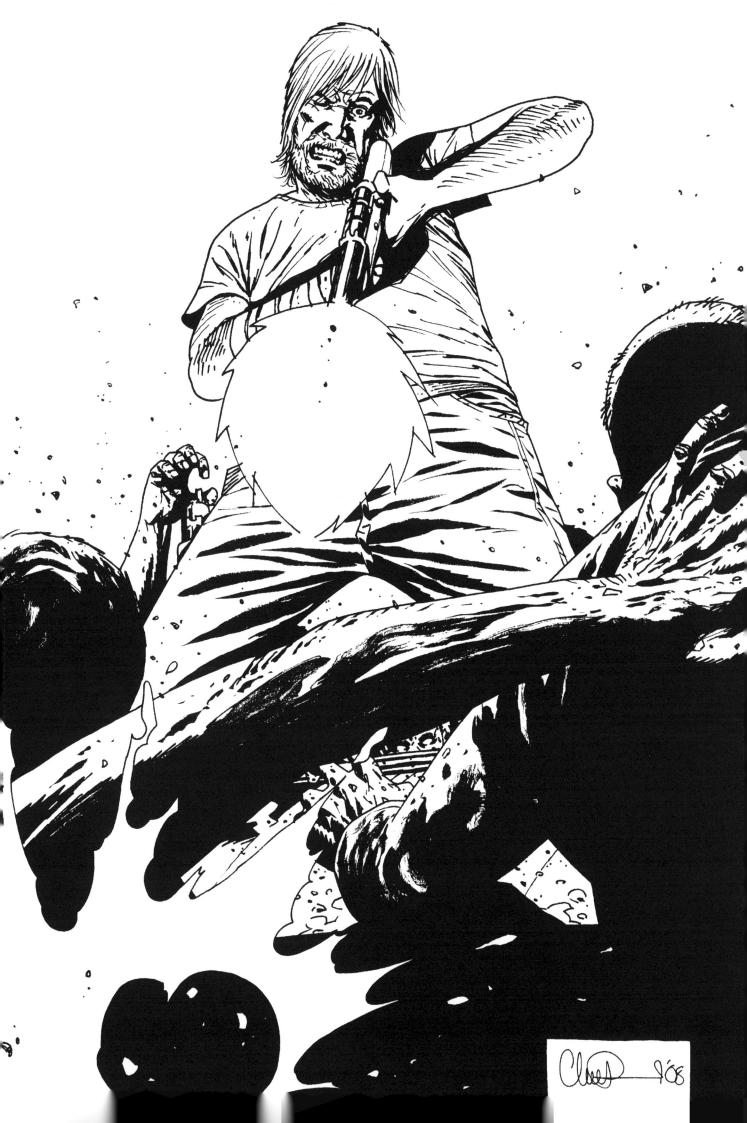

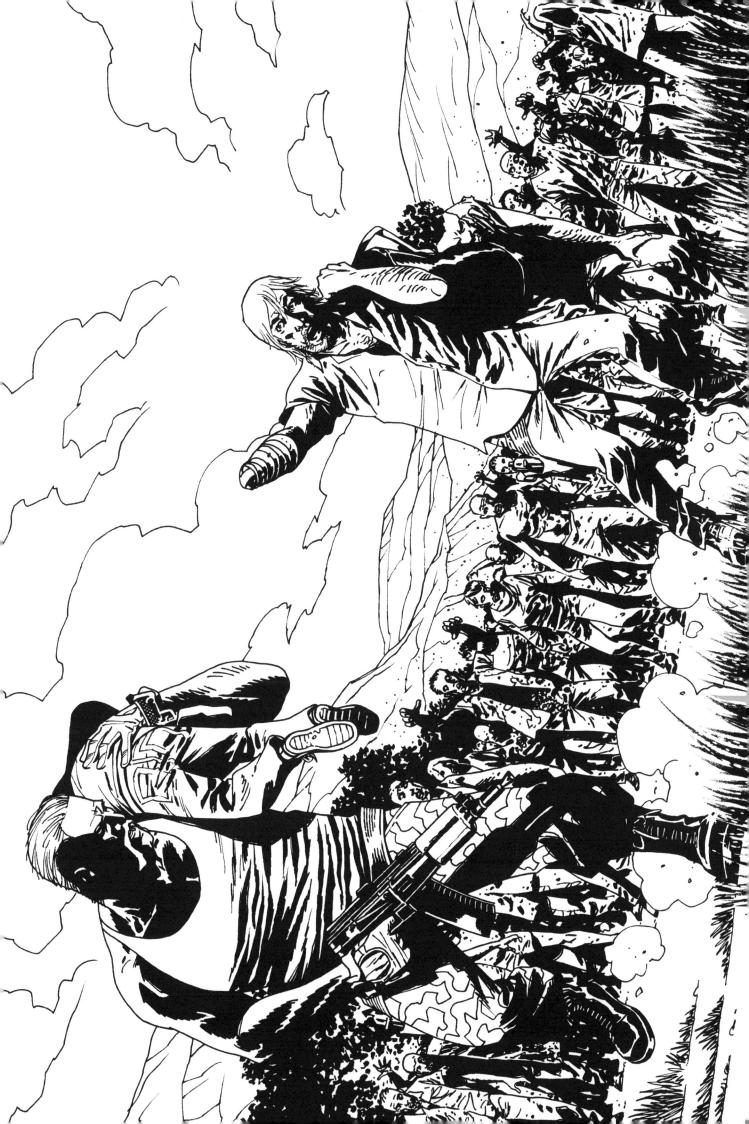

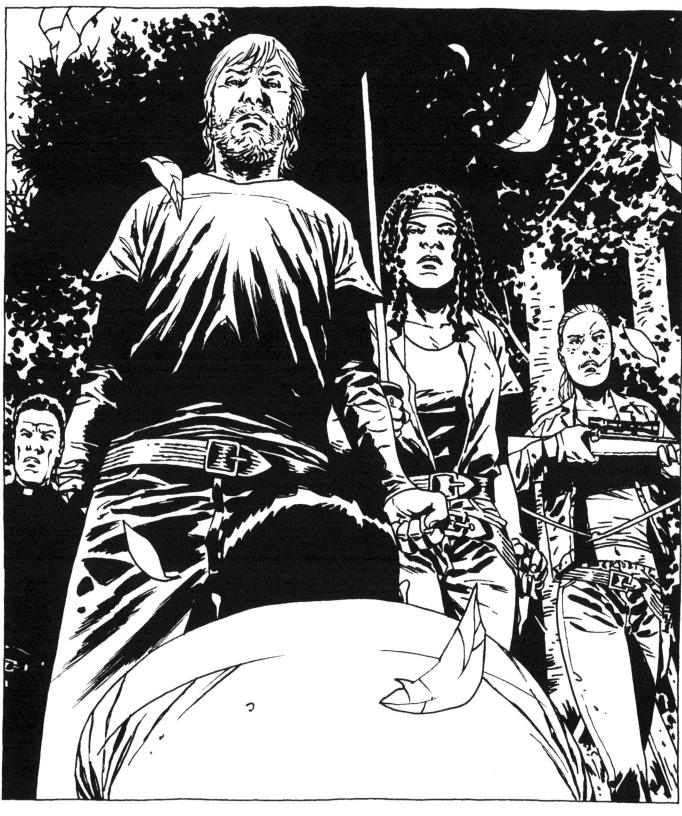

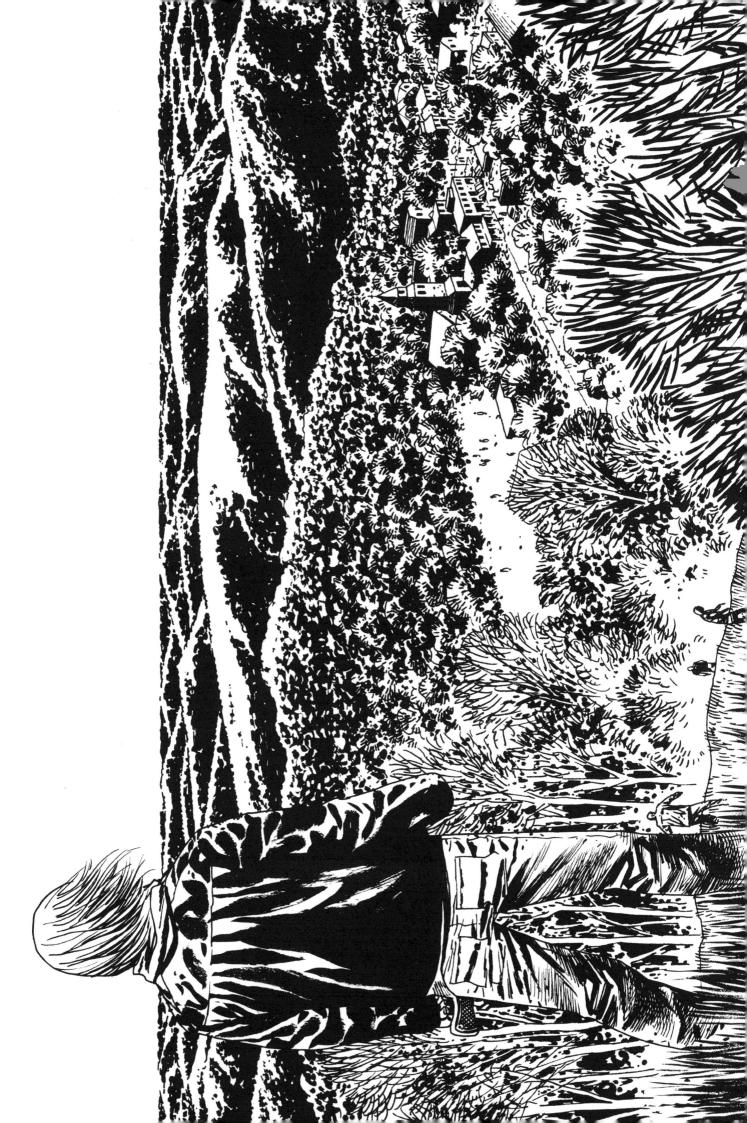

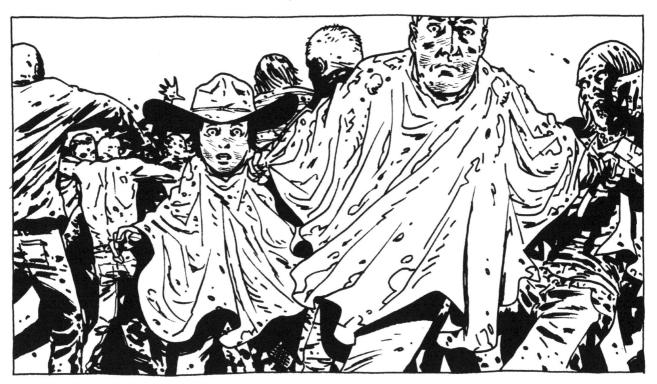

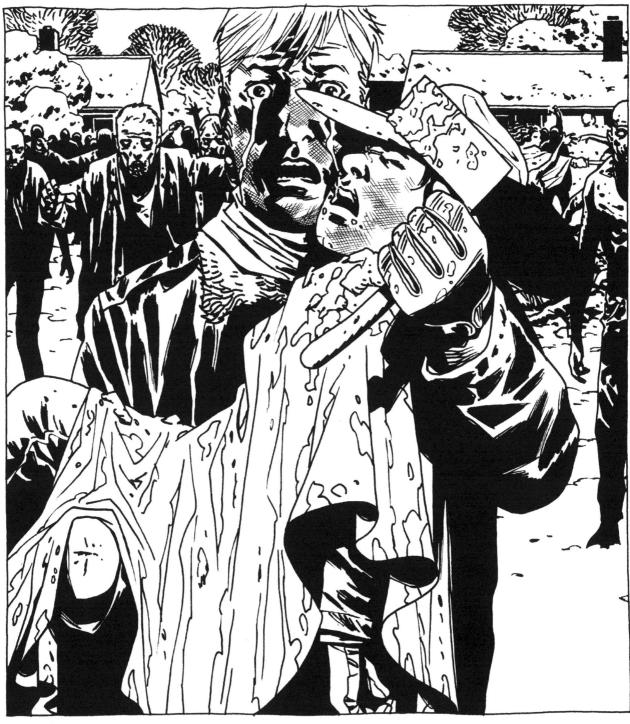

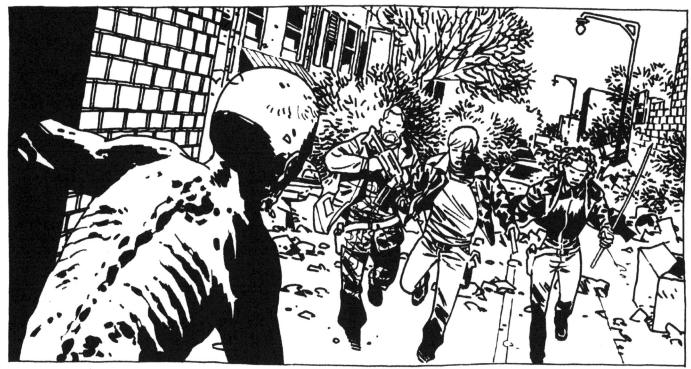

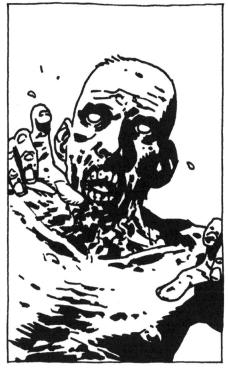

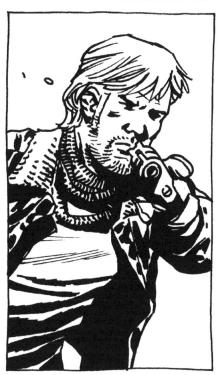

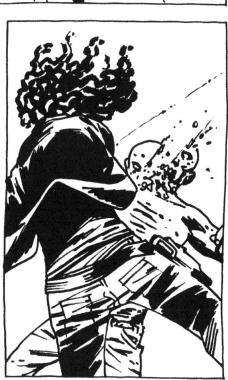

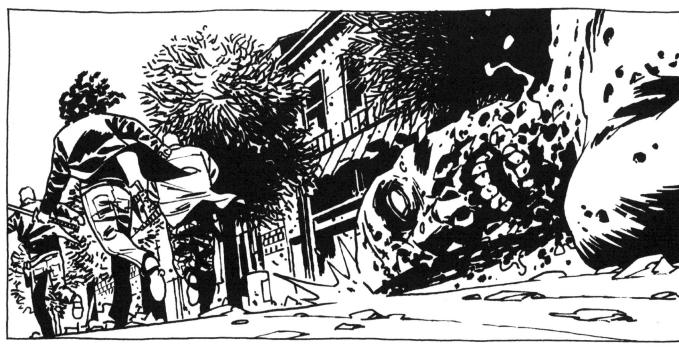

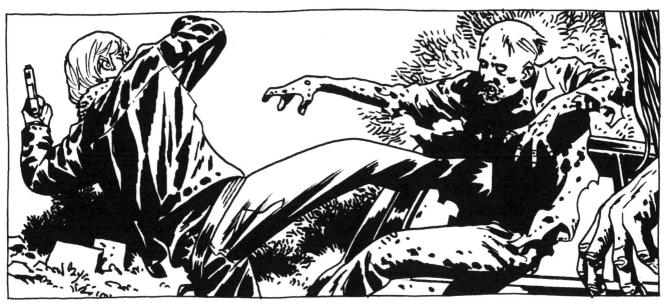

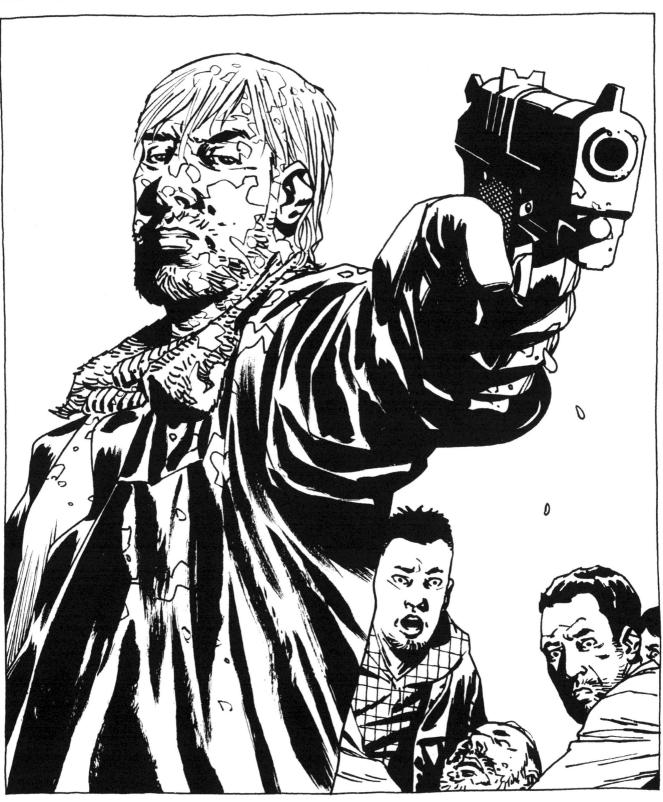

•

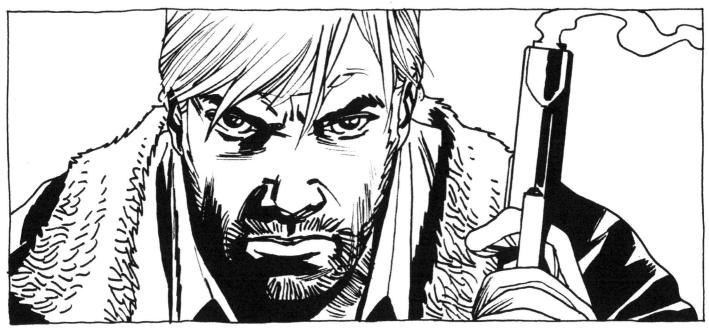

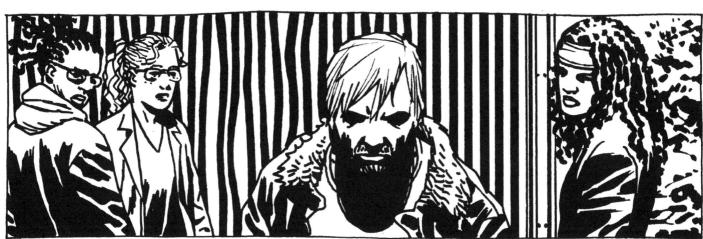

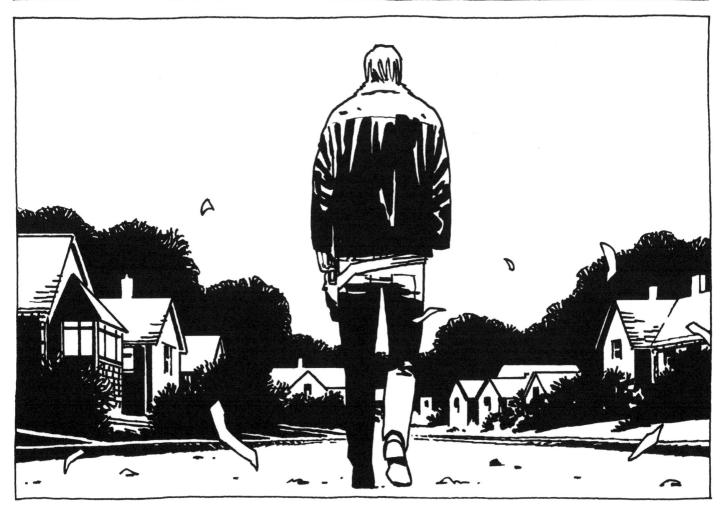

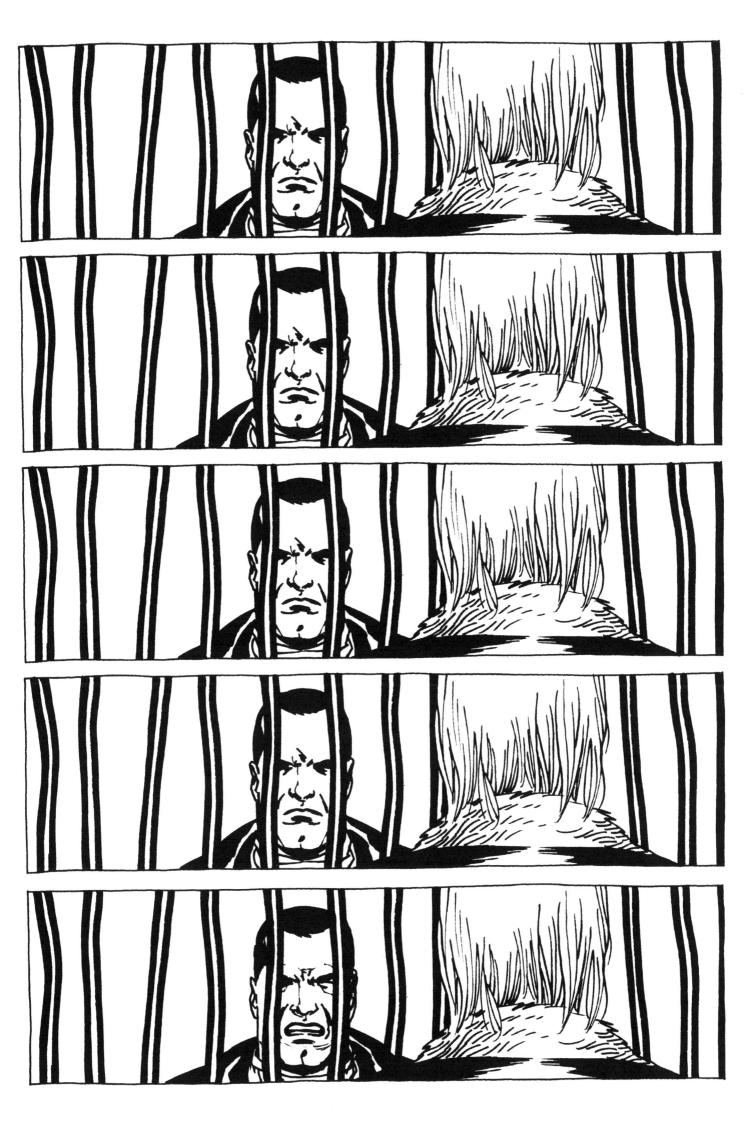

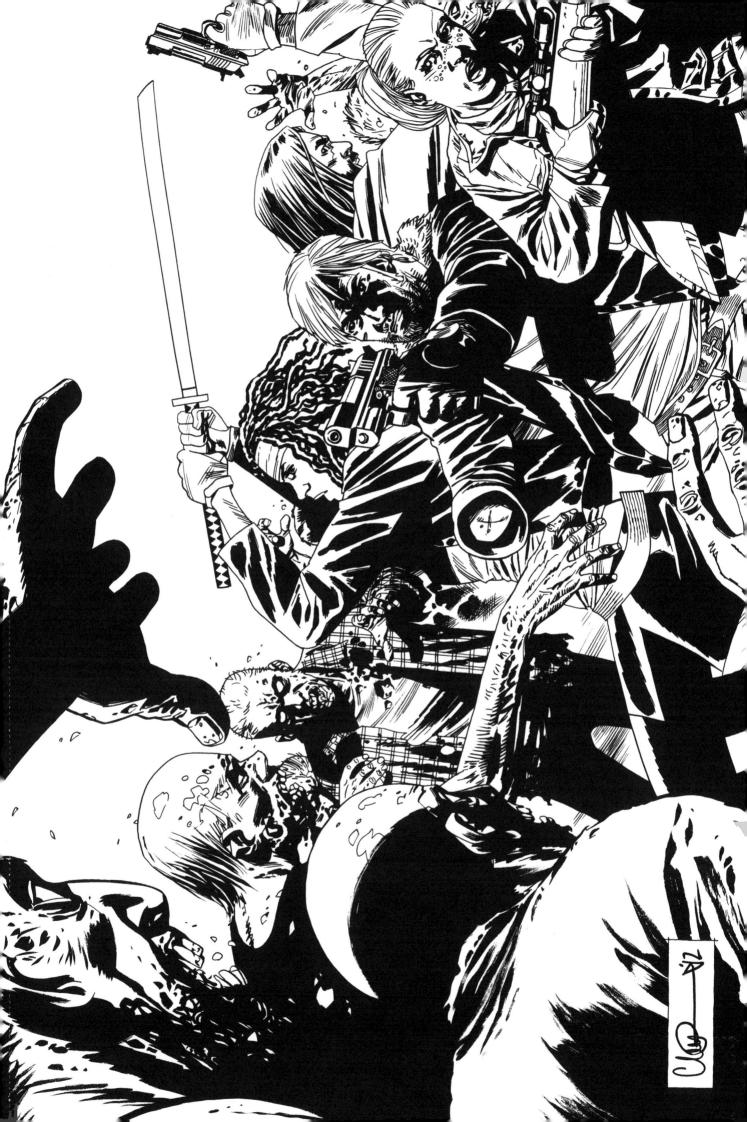

		*		
	*			
				1

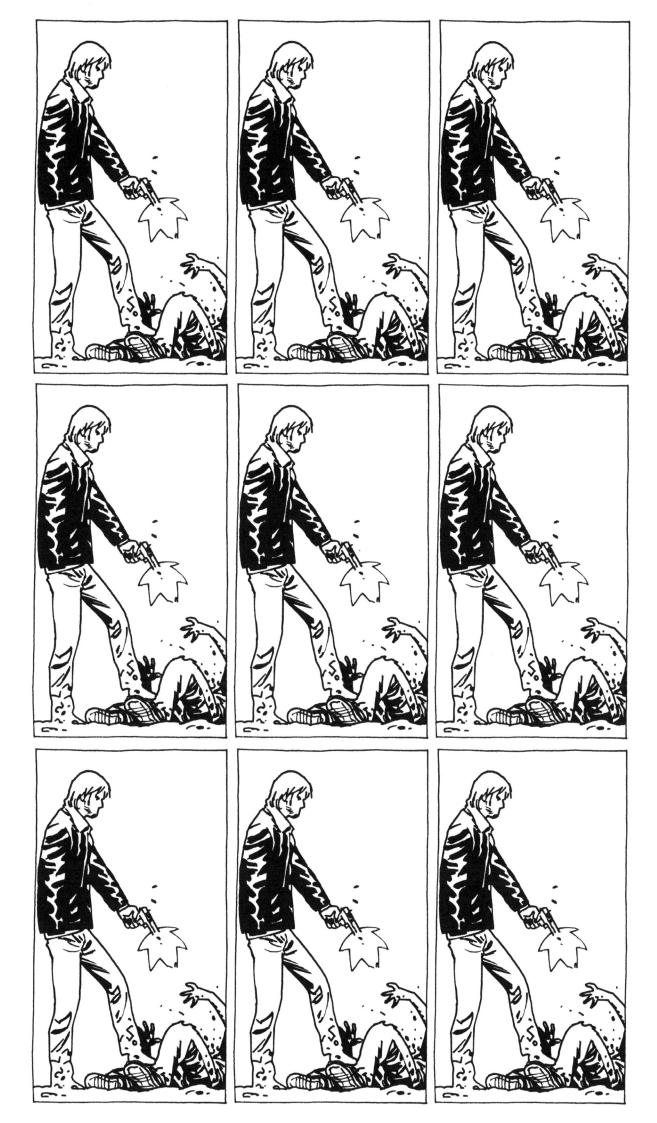

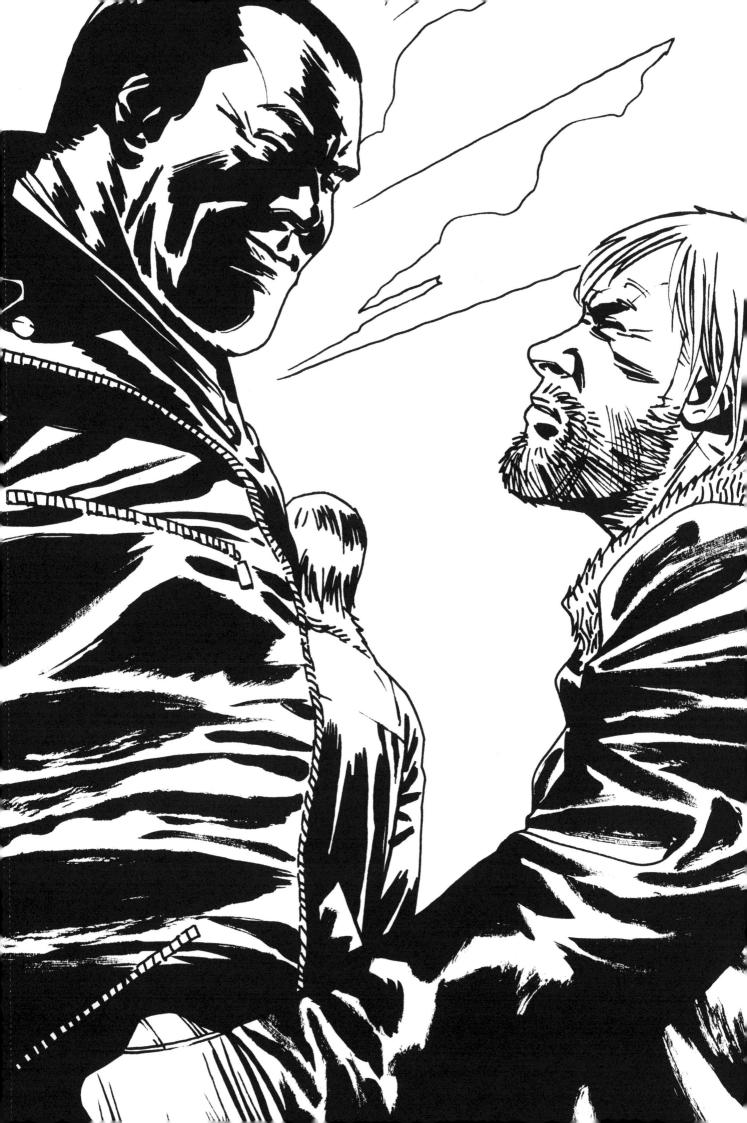

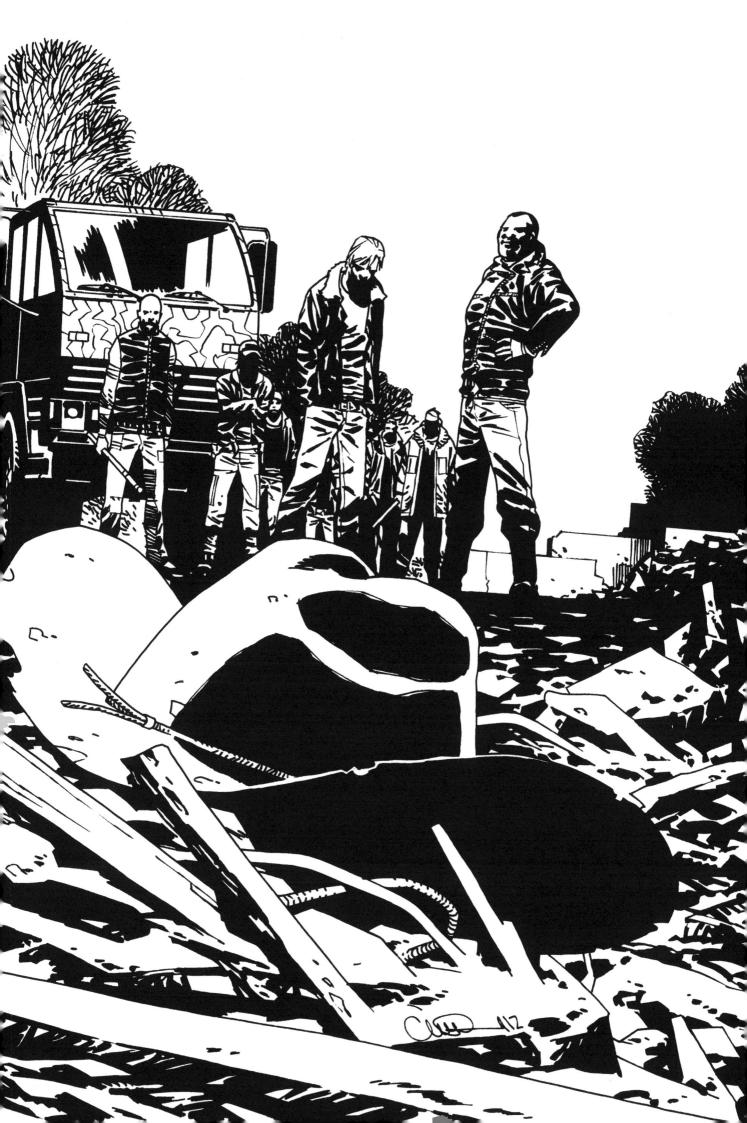

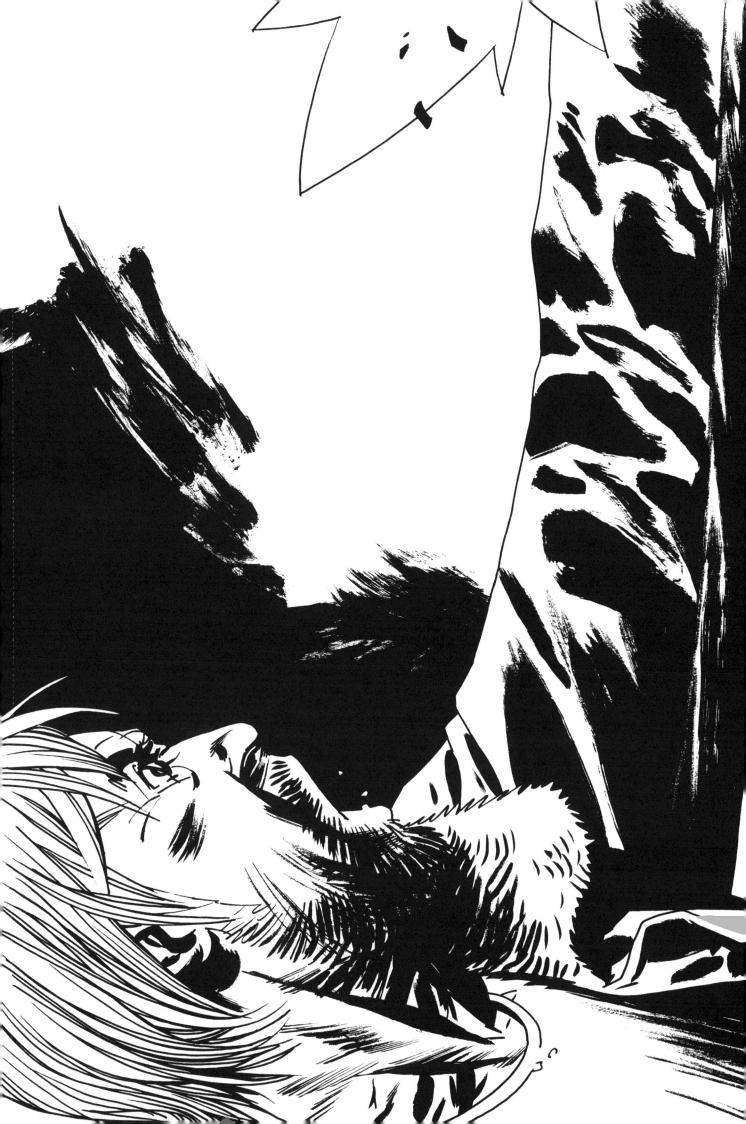

		• 9.7

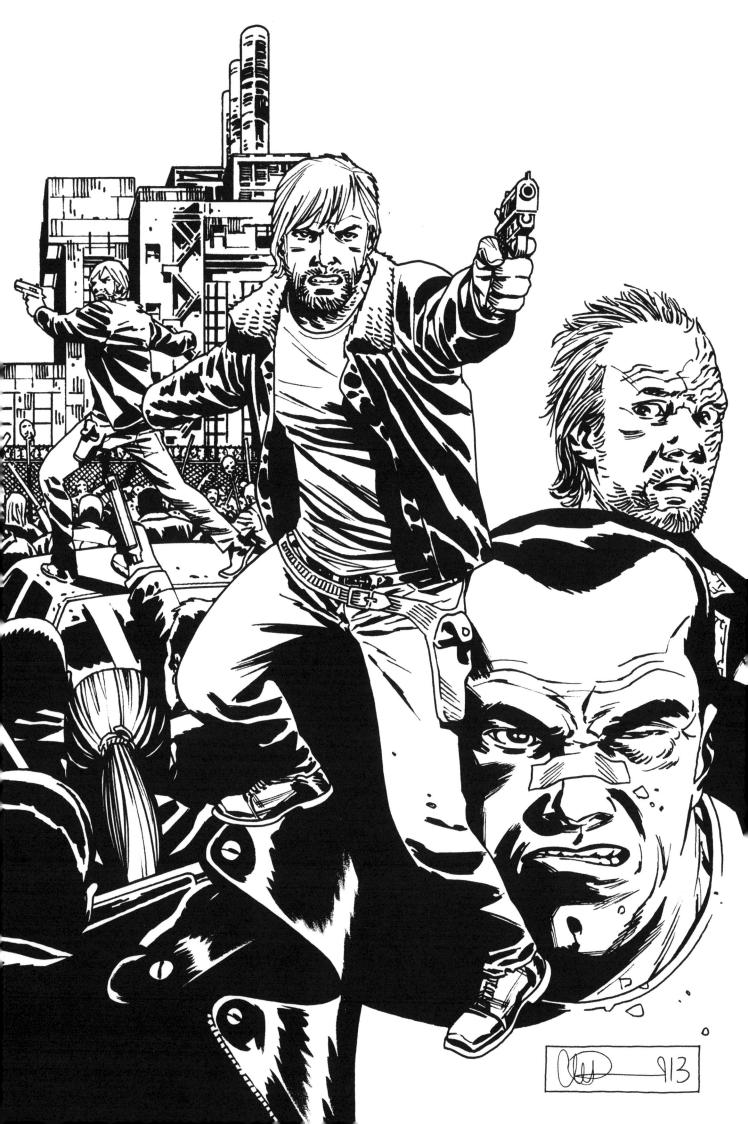

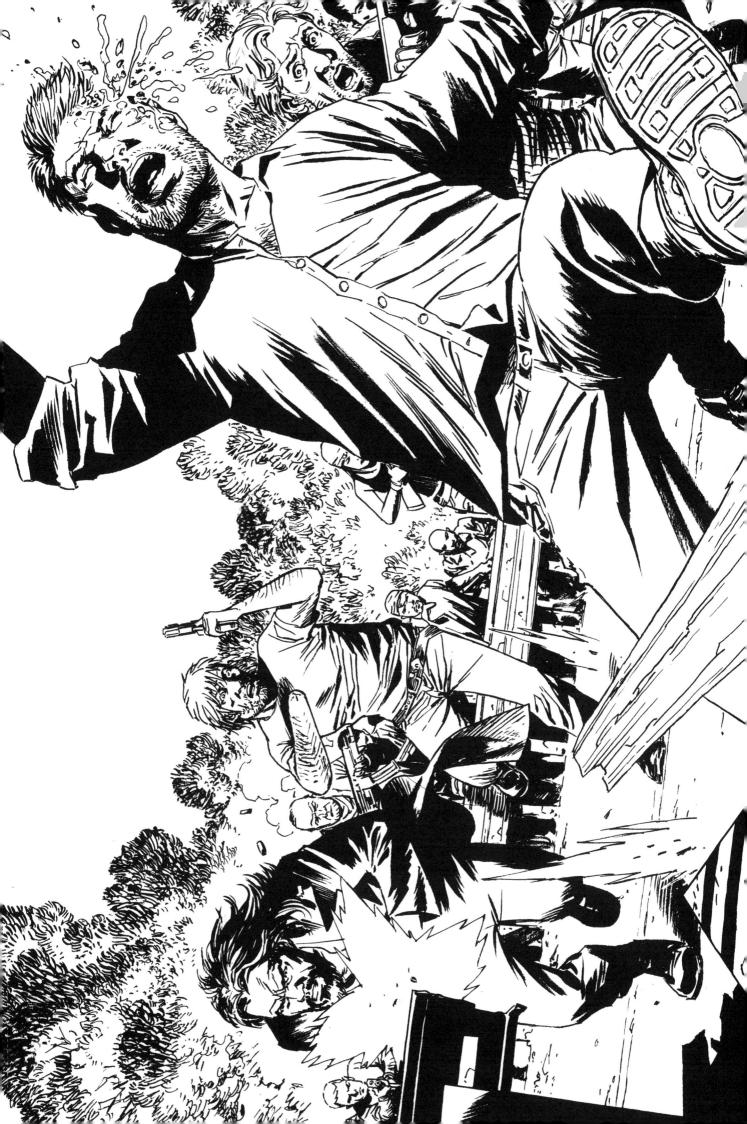

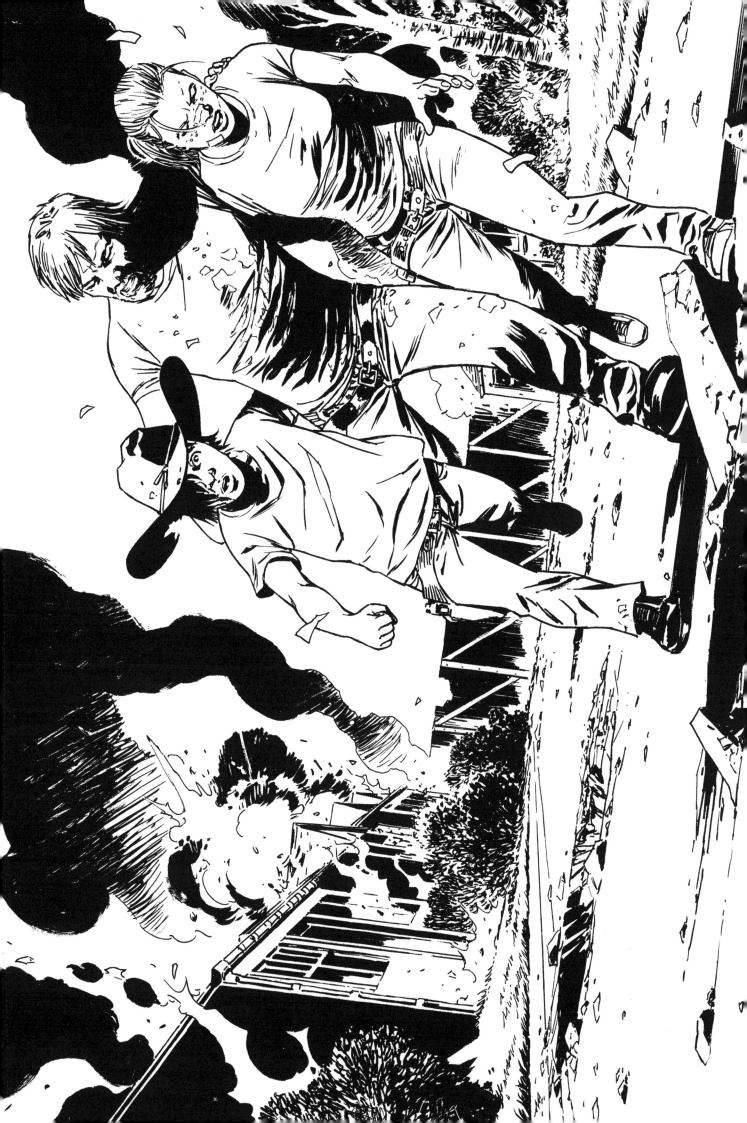

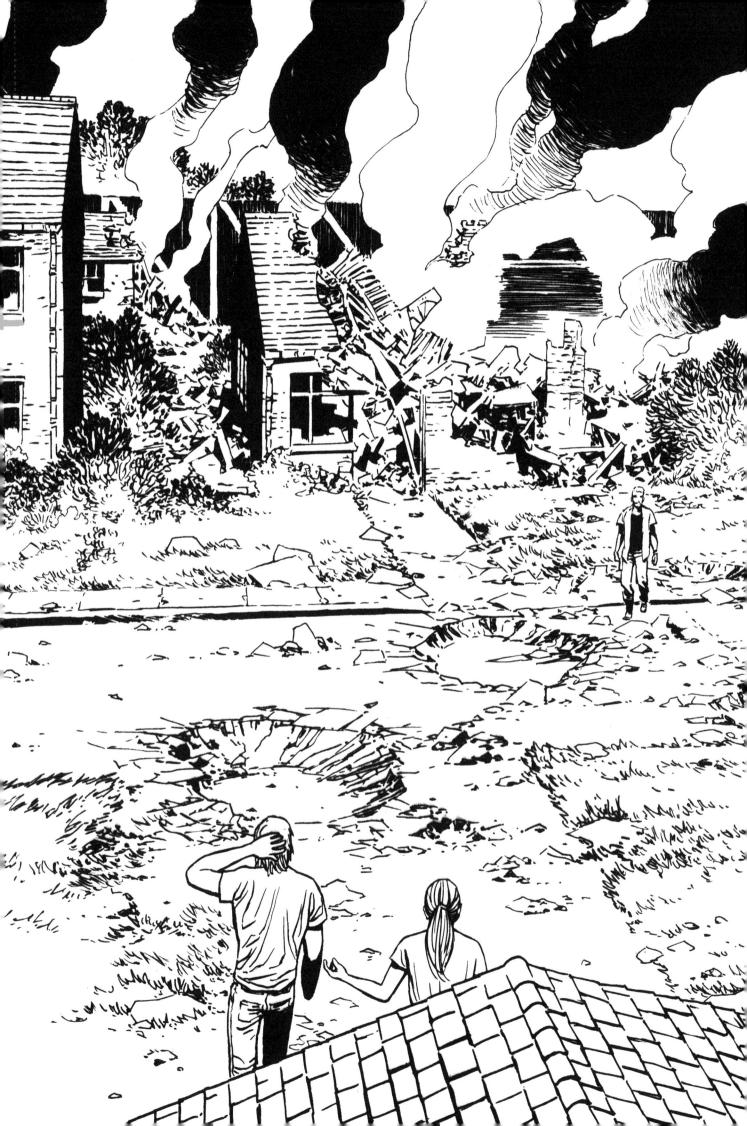

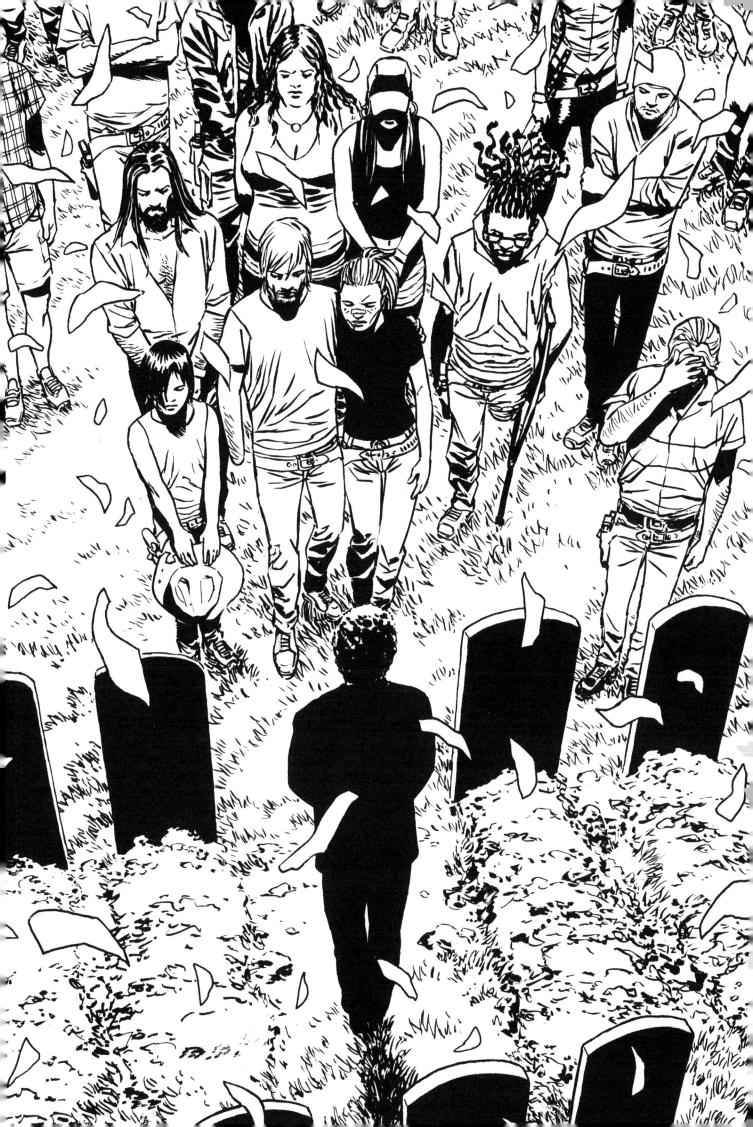

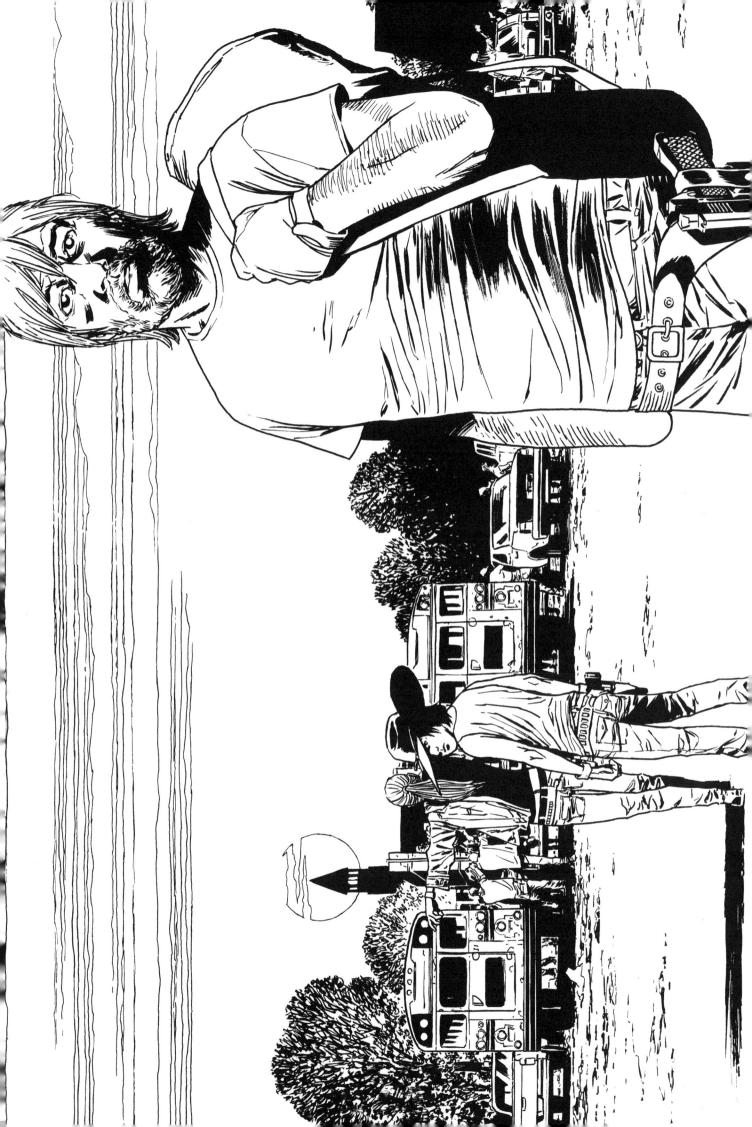

.

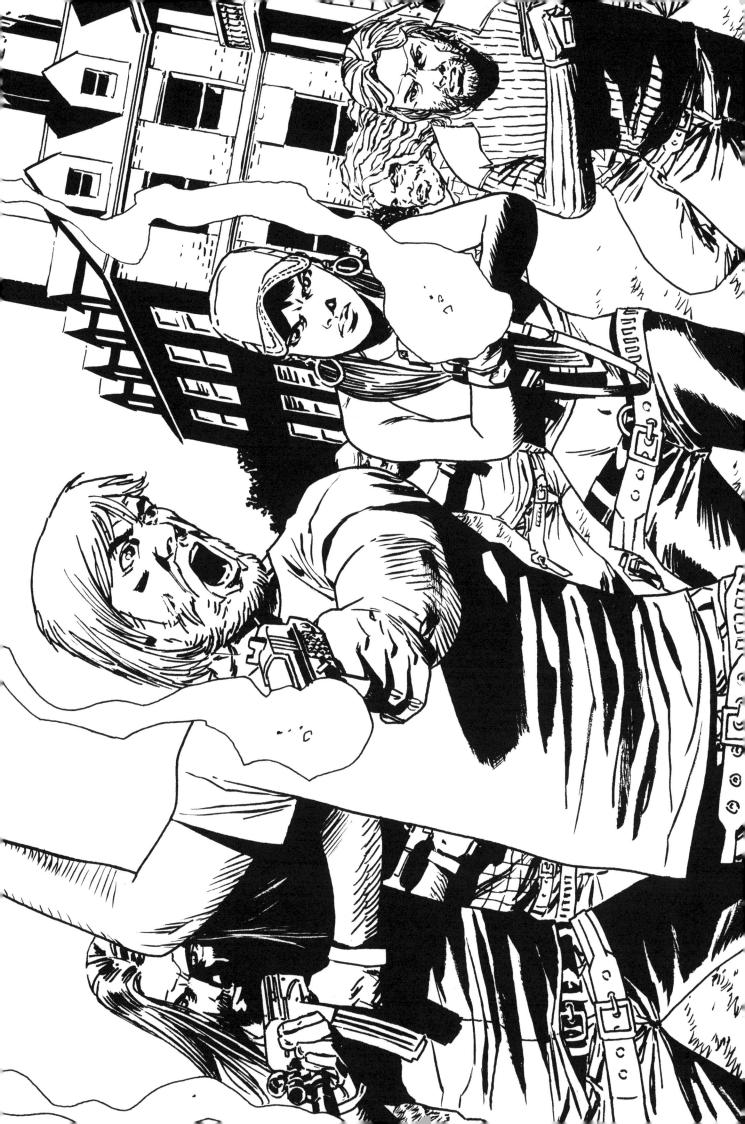

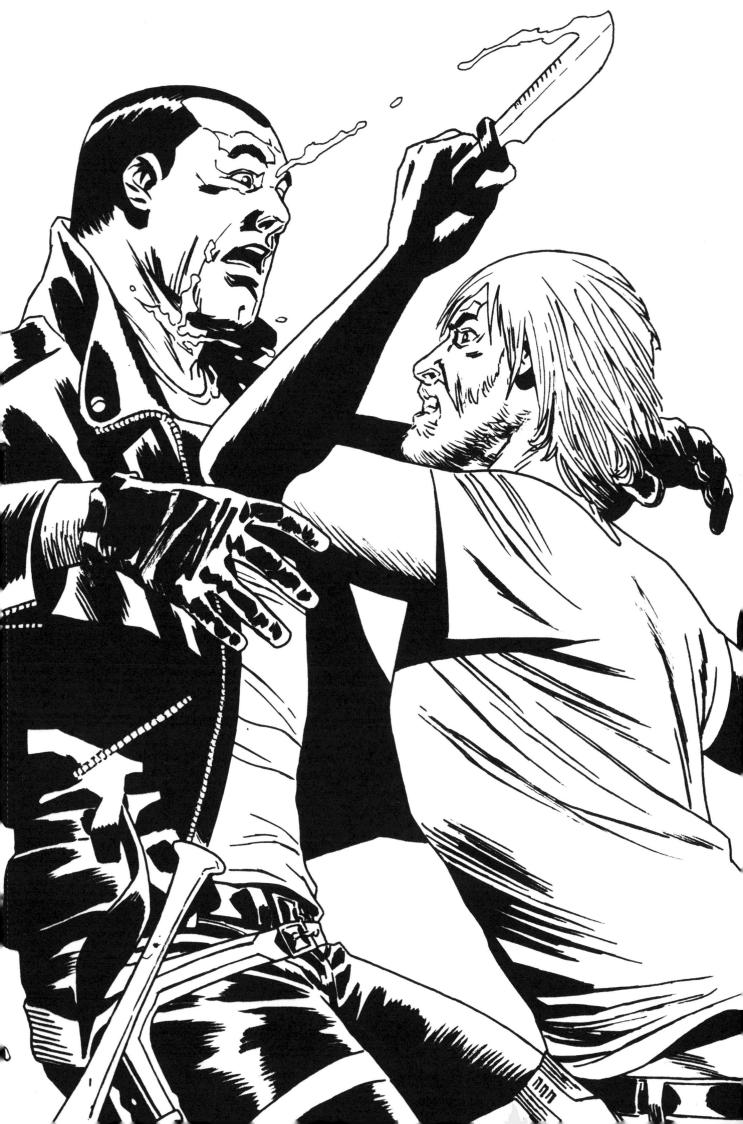

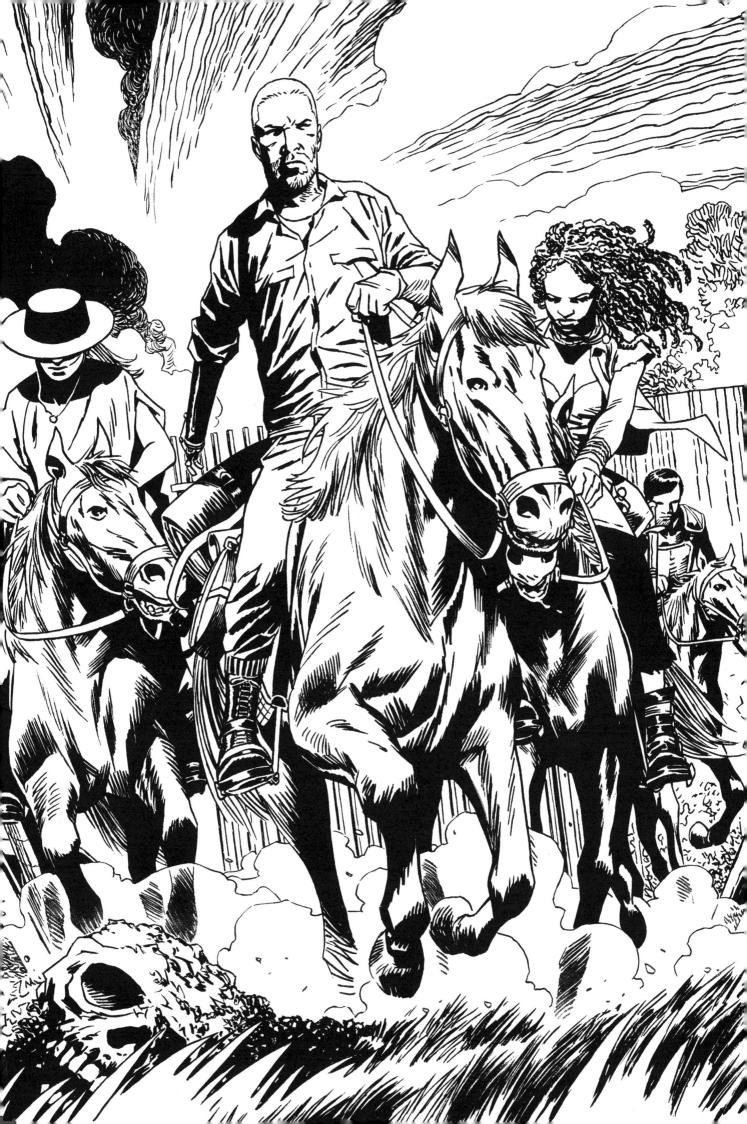

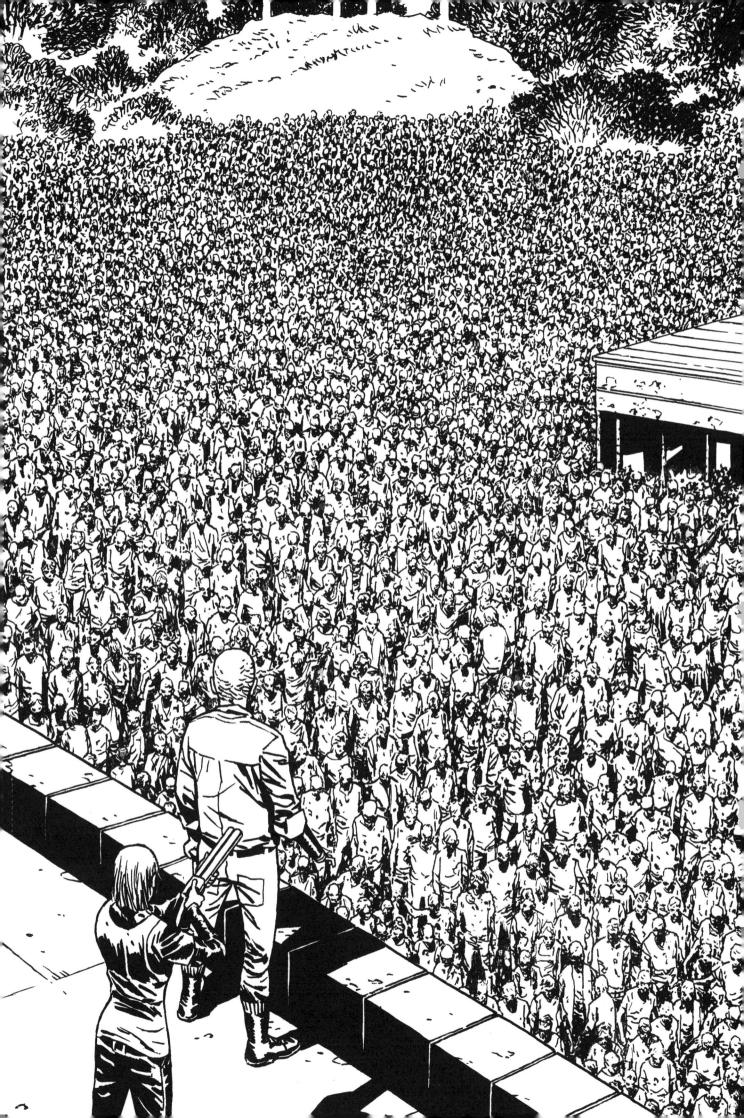